Water's Edge

OPEN TO INTERPRETATION

PHOTOGRAPHY JUDGE / DOUGLAS BEASLEY

WRITING JUDGE / ANASTASIA FAUNCE

INTRODUCTION BY CLARE O'NEILL

Published by Taylor & O'Neill
599 Laurel Ave, #6
St. Paul, MN 55102
phone: 651-312-0113
email: info@open2interpretation.com
www.open2interpretation.com

Design: Joseph D.R. OLeary / www.vetodesign.com
Editor: Anastasia Faunce

ISBN: 978-0-9848064-0-9

Printed in the United States.

Water's Edge

OPEN TO INTERPRETATION

CLARE O'NEILL

As a photographer, the comment I hear most often regarding my work is, "your photographs tell a story." But I was never sure what story the image was telling. So I started to ask what people saw in my images. I was fascinated with the varied narratives that different people would attribute to the same image. I realized that I was creating moments in which the viewer could participate — inviting them to imagine what comes before and after the shutter is released.

At its most sublime, art can transport us to a time, a place, a feeling, or a memory. It may be the entire image, or the smallest aspect of the image, but we are reminded of some profound connecting thread; it becomes a commentary on our lives: past, present, or imagined.

The title and framework of this project, *Open to Interpretation*, addresses both the human impulse to create art, as well as the urge to try to define or make sense of the work created. I recently learned from my friend, art historian Cynthia Bland, that we are still trying to interpret the meaning of prehistoric cave paintings. Because the paintings predate written language, we will never know the true intent of the imagery. We are only able to interpret the images as we imagine the past to be, and bring our own lives into the picture.

Did women paint the images while men were hunting, hoping to symbolically affect the outcome of the hunt? Were the painted animals a prayer of petition to keep the herds in abundance or factual records of seasonal change? Or were the animals depicted on the walls used as initiation rites or instructional tools? We simply don't know and likely never will. What keeps these prehistoric cave paintings alive in our cultural imagination is the fact that they remain open to interpretation. The imagery gives us important information about our collective past, and it is up to us to discover what it means for us today.

What we do know from our prehistoric origins, is that artistic expression has been a primal need, a tool to share our experiences. Inherent in its very existence is the ability of art to engage and inspire the viewer; the power and meaning of art doesn't lie solely in the mind of its creator.

To quote Picasso: "A painting is not thought out and settled in advance. While it is being done, it changes as one's thoughts change. And when it's finished, it goes on changing, according to the state of mind of whoever is looking at it."

Art continues to change in accordance to the viewer who perceives it. Each individual, through varied life experiences, offers new and different understandings to a work. Art constantly evolves as each individual contributes their own richly textured interpretations. It's not telling us things we don't already know, but rather, reminding us of what we do know, or may have forgotten. What then, is the role of the artist? Does the artist imbue the work of art with meaning or does the meaning reside within the viewer? What, if anything, is intrinsic to the art itself? Does our interpretation say more about us as viewers than it does the artist as creator?

By introducing layers of interpretation, this project encourages us to think about the way we view and understand art. *Open to Interpretation* investigates the power of visual imagery to tell a story, and was the concept of my first solo exhibition, which paired 12 images with 24 stories and poems. I found the interaction between the images and narratives combined in such a way that when together, they were stronger than they had been independently. At first I thought it was an interesting twist to an exhibition, but later found the words added another dimension to the work — allowing me, as the artist, to rediscover the image in ways I had not imagined.

This book, the first in the *Open to Interpretation* series, began with a call for photographic entries to address the theme *Water's Edge*. More than 1500 photographs were submitted, and Douglas Beasley, founder and director of Vision Quest Photo Workshops, oversaw the selection of photographs. Once the finalists were established, 203 writers then submitted their interpretations of the images in either poetry or prose. Anastasia Faunce, a writer, editor, educator, and arts administrator, chose two written narratives for each photograph.

The themes that emerged during the process were as varied as the images themselves, and ranged from the literal to the abstract. It was during the writing selection and review process that it became obvious that some photographs elicited a greater response from writers than others. Several photographs generated dozens of entries, while others had relatively few. This prompted such questions as: Why do certain photographs ignite a creative response in a writer? Do some images tap into basic human drives and speak more viscerally to our collective human understanding? Or are some images more visually powerful than others?

The pairings offer the reader different points of entry to each image, opening a dialogue between artist and writer, image and audience. We need to ask ourselves then, can the written narratives be open to interpretation as well, or are the narratives closed?

Open to Interpretation invites artists, writers, and audiences to collaborate in this exchange. It taps into fundamental questions about how we perceive, experience, and interpret art. The power of this project is evident in its global reach. Nearly 500 participants, from 25 different countries, and 40 states, submitted their work for consideration. I believe that viewers and readers complete the work. This collaboration deepens our investigation of each work of art, allowing us to be active participants. Certainly, the narratives presented here, whether pictorial or written, remain open to interpretation.

— Clare O'Neill, Publisher

What we do know from our prehistoric origins, is that artistic expression has been a primal need, a tool to share our experiences. Inherent in its very existence is the ability of art to engage and inspire the viewer; the power and meaning of art doesn't lie solely in the mind of its creator.

Photographer
Agnieszka Sosnowska

SELF-PORTRAIT IN THE YORK RIVER, MAINE

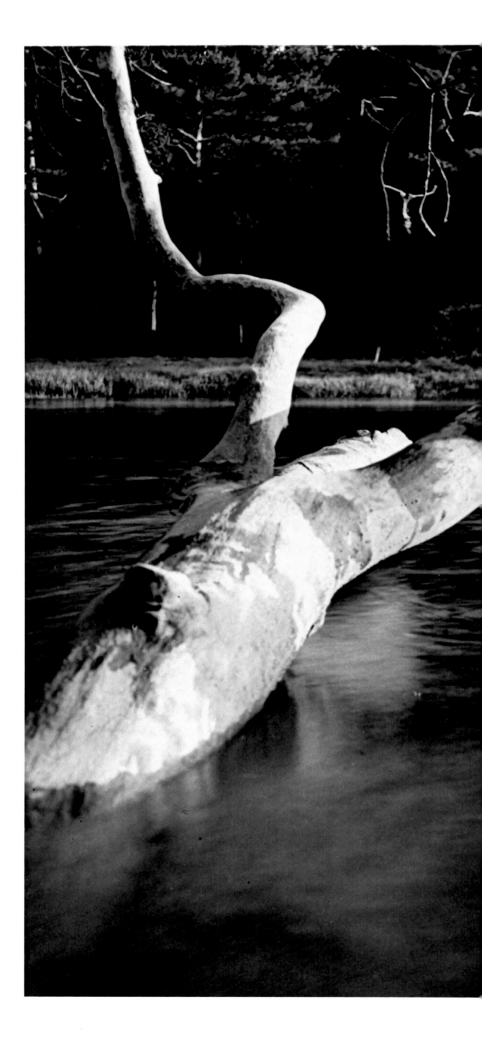

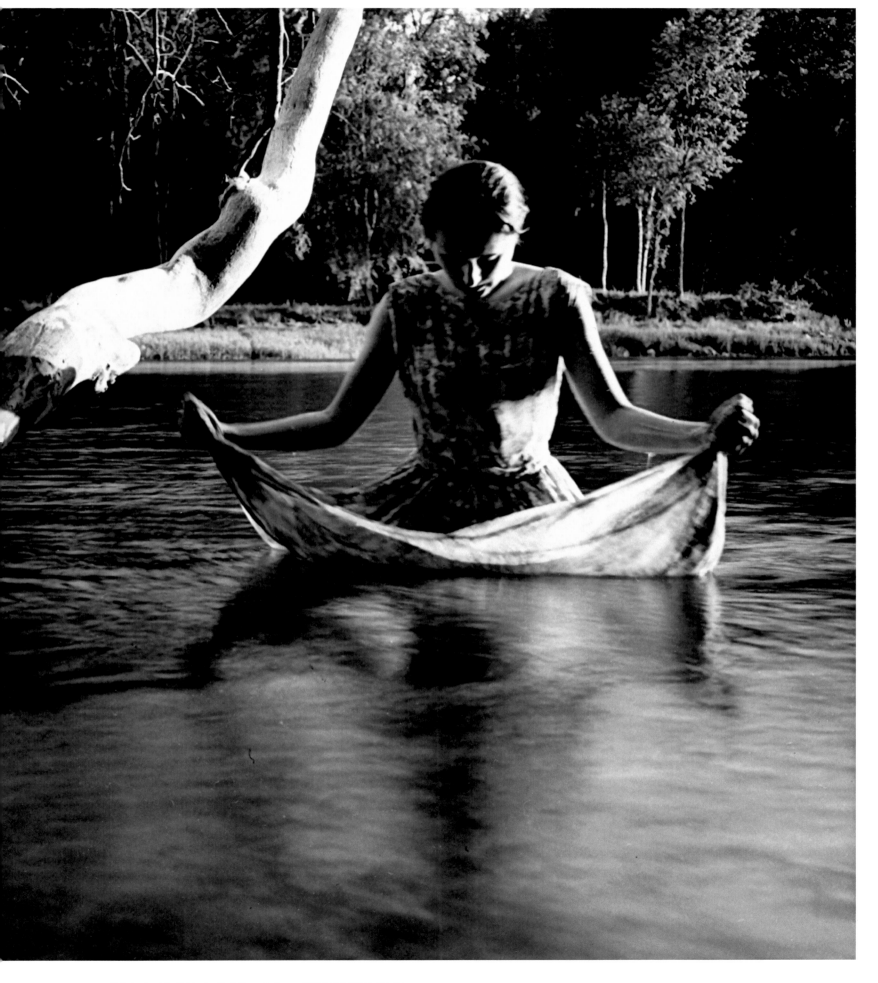

Writer
Kris Bigalk

MISCARRIAGE

Here, in the river, the backwater,
despite lye and bleach, the blood stain
still an outline of rust,
like the map of a lake
sketching the contours of my lap.
I never could get anything quite perfect,
always the impatient cook, the roast bleeding
onto the plate, cold to the touch
in the middle,
my porcelain sink discolored
with rust circles, crusted with
scales of lime. I scrub and scrub
but the ghosts come back,
my goblets glazed
with milky soap residue,
the very bottom of the globes
stained with dried red wine,
like my uterus once filled
with salt water, now
draining dry, this dishrag, my skirt
stained with its dregs,
the taste of iron weeping
from my tongue.

Writer
Cynthia A. Graham

SKULLBONE CREEK

All the water in Skullbone Creek could not wash away the sin of Sally Hawkins. She was just the sort of woman everyone called *exemplary*. Her home was spotless, her children polite, and her husband well-satisfied. The unseen Sally was as mired as the mud of the creek that squished between her toes as she stood there. Sally's great sin lie not in her actions — she was no succubus. Faithful to the husband of her youth, she had given him five children; with every child nursed, another tooth lost from her jaw. Her sin was not borne in her words — her conduct was becoming of the wife of the minister she had wed — her speech was seasoned, as it were, with salt. The great sin of Sally Hawkins lie in the inconvenience of having a great mind in a time and place where such a thing was not valued, and was moreover, discouraged. She would have done well to never marry, but the thing was decided by the untimely death of both her parents and the need for sustenance. The newly widowed Reverend Hawkins looked upon the child with that delicate and odd combination of lust, domination, and pity that is found only in the male of the species, and Sally was rescued from one sort of poverty only to be delivered to another. For twenty years she had been a diligent wife and mother. Yesterday, the last child of the household was wed and today, Sally stands in Skullbone Creek. For too long her life has been one of acquiescence, but on this day, the baptism will be her own. And Sally Hawkins sank into the water of Skullbone Creek and let it swallow her.

Photographer
Colleen Leonard

ZEN PUDDLE

Writer
Carolyn Cray Arnold

YES, YOKO!

She enchanted John with the profound and simple word *Yes,* a reward for being curious enough to climb the ladder. Yet, I never appreciated Yoko Ono as an artist. She was so avant-garde. The Fluxus movement confused me. Her films were just plain strange and the caterwauling was an embarrassment. And of course, I blamed her for interfering with my beloved Beatles.

Then I went to an exhibition of her work and the scales fell from my eyes. One piece in particular has stayed with me — it gave form to a long-held belief that I have often struggled to express. Encased in museum plexiglass, was a Cartier box opened to display two perfect acorns. Yes, Yoko! How simple! What genius!

We fall all over ourselves trying to combine the ultimate words, render the consummate image, hit all the right notes: fussing and fluffing, editing and revising, adding too much, working it to death. And yet, the ideal we are striving for is there. All we need to do is open our eyes and accept.

Writer
Ana Mae Bellisio

IN A BAY OF THE GOLF

The phantom petals of Pound's wet, black bough;
Fourteen words, no verb, Imagist precision.

Writer

Photographer
Yoichi Kawamura

UNTITLED

Writer
Barrie Jean Borich

CREASE

As a girl I walked waterlines, sometimes on sand along oceans, sometimes on the paved paths downtown, between Lakeshore Drive and the waves, always parallel to the groove where destination folds into the present tense.

When I walked the Gulf Coast beach for the first time, age 15, I was that girl from the cold city, tanning too quickly in her stringy striped bikini, bare feet marking sand, sun-blond and uneasy in her long swimmer's body — no tattoos yet, or surgeries, or histories of love.

The crease is what the gaze inhabits but the body cannot. I walked out of time, stepping forward and forward again, for longer than I thought I could keep on, knowing I'd have to walk back again, past the same greased-up college kids, screeching mothers chasing toddlers into the surf, future architects building shell cities and burrowing limbs into the sand. The gauzy line, amber interrupting blue, hovered over first my right shoulder, later my left, the crack of waves standing in for the end of things.

I see her now, that blond girl, walking, pretending not to notice men watching her, the way men gaze after blond girls in bikinis, or after the figments they make of blond girls. She will not remember if she longed for any part of those bare-chested linebackers, collarbones glinting with Italian gold, their bodies taut as they dove into the breakers. She will only be sure of what she did not want: their babies, their houses, their hovering mothers, their jealous breaths in her ear.

Though she may have wanted their wanting, as I do sometimes still, hoping to be seen as much as anyone walking the crease of future's plainness, even knowing too well the difference between fascination and erudition — that interruptible blue.

Writer
Kristen Radtke

UNTITLED

Refracted motes of light wander the floor in ghostly bluish orbit. Kept dark for the clearest exhibit viewings, the aquarium fills with the churning of filtration and buzzing of air-conditioned muteness. Jellyfish curl translucently through thin circular tanks, too fragile for squares and edges.

A great white shark is the aquarium's newest, yet temporary addition, still young enough not to kill his companions. For now, he is content to eat what his keepers bring. He swims the surface to devour the ground-up dead things, and in a few months he will look around the tank and recognize prey where he once saw only movement.

"What is it about water," a man next to me says to someone else, "that makes everything seem so empty?"

Steel schools of tuna swim walls of glass as we stand in line, watching.

"It's so pretty," says his someone else. "I could die here."

Photographer
Seamus Mullen

UNTITLED

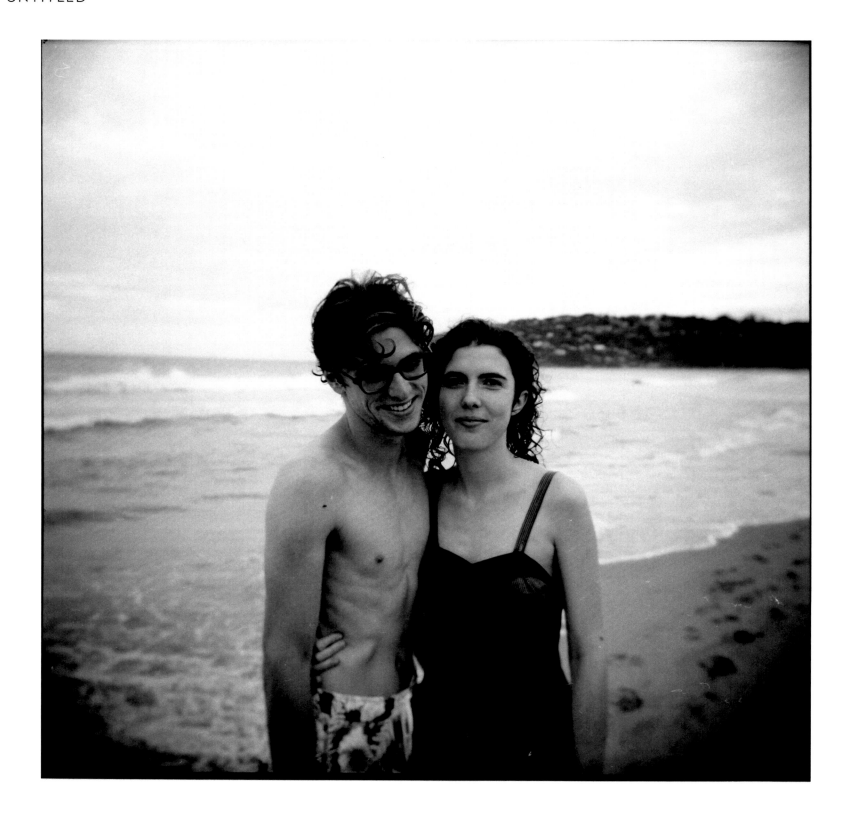

Writer
Johanna Commins

UNTITLED

That summer he made her tiramisu as a surprise, because it was her favorite. He'd brought the mascarpone, icing sugar, lady fingers, and Marsala wine; the eggs and strong coffee they'd already included amongst the breakfast things. He even remembered to pack the special glass dish he liked to serve it in, and cocoa powder — the good stuff — for sprinkling on top. But on that day, he realized he'd forgotten vanilla essence. He dithered for a while, wondering if he could leave it out, before deciding that the tiramisu wouldn't be quite right without it.

He'd driven the manual up the steep, steep road from the beach. He enjoyed flirting with third gear before settling back to second. He rode with the window down, the cranky old stereo blaring. He left her reading on the beach.

They ate the tiramisu after dinner with the second bottle of wine. They sat out on the porch, citronella candles burning to keep the mozzies at bay — the sea lapping at the shore. Later they had sex and went to sleep.

Sometime between 3 and 4 a.m., he woke up and she was gone. He stood with the fridge door open, arm resting along the top edge, the light spilling onto his naked skin. He ate tiramisu out of the dish. One teaspoon. Then another. And another.

She got as far as the next town before she pulled over and lit a joint. The familiar action soothed her, the tiny glowing ember became a focal point in the dark. She was on a country road, heading nowhere. She'd only grabbed a jacket, her handbag. The rest of her things were spread untidily across the apartment. It would be just as easy to turn back as to keep going.

Writer
Abigail Stokes Palsma

FANNY DUBOIS, GONE CARTER

To be clear: I'm Fanny Dubois now. Fanny Carter is a person of the past.

One thing I miss from those days is our bed, Jack's and mine. I have slept on more expensive beds, but that queen-sized, aging mattress beats all. Heavy and thick, the headboard and footboard were not really my style, but the large spheres on the corner posts fit perfectly in my hand. I pressed my palm wholly to the orb each time I walked by and somehow felt more grounded as a result. Over time, I rubbed away the finish with this ritual.

When Jack traveled, I made snow angels between the sheets to double my body heat. The white quilt was not quite thick enough to keep me warm when alone, but it had enough weight to hold us there together. I also switched the pillows. Jack's held his scent. It wasn't cologne, because he never wore any. It was just the essence of him and his pomade. At first, I didn't like the smell; but over time, the musk and oil became a comfort — especially when he was gone.

Jack died six years ago, and now, here I lie in a strange hotel bed with a new husband on our wedding night. Lance is wonderful and I love him. But this bed is not ours, and I don't yet like how he smells.

Photographer
Elizabeth Brooks Barnwell

CHLOE

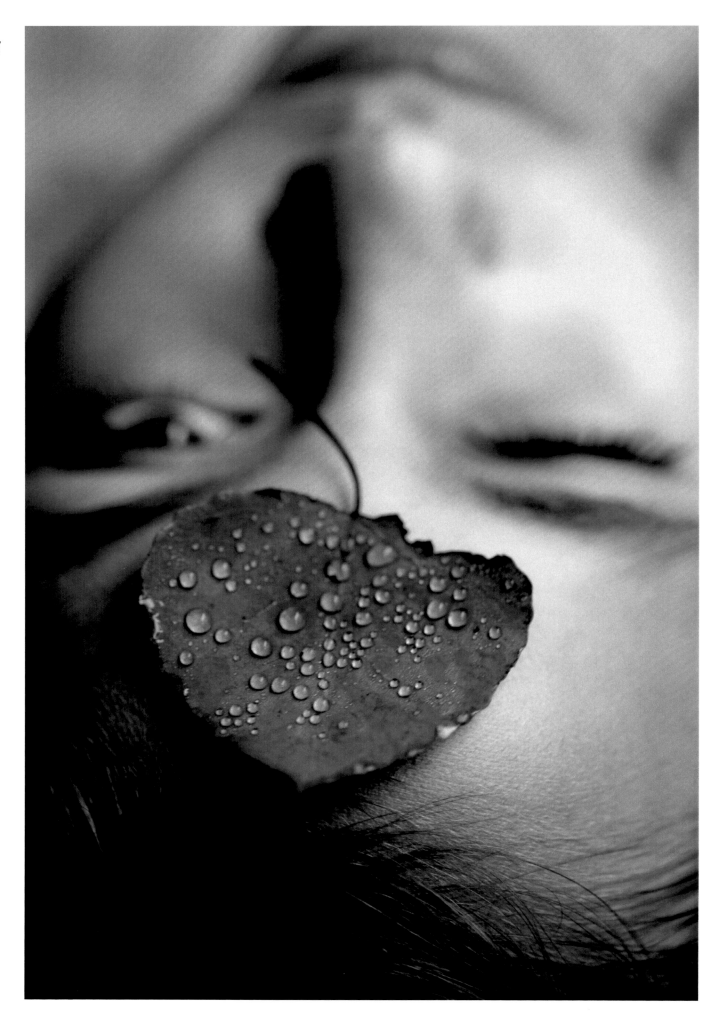

Writer
Paul Mattes

UNTITILED

It is fundamentally human
to treasure the ephemeral,
the improbable,
a coincidence of things
that should not be,
to know it is beautiful,
and hold it deeply,
and gladly spend a lifetime
hoping to find another.

Writer
Kris Bigalk

A DISSECTION OF FAITH

One half relies on the details
of photosynthesis
a religion of chlorophyll and light —

the other half is
held up by oceans.

A leaf, a stepping stone, leading flesh
to air, focusing the mind's eye.
See, an entrance to a tree knot,
the scent of sweet sap
circling like a catacomb.

Photographer
Mark Jaremko

NIGHTSCAPE 1, 9:43 PM

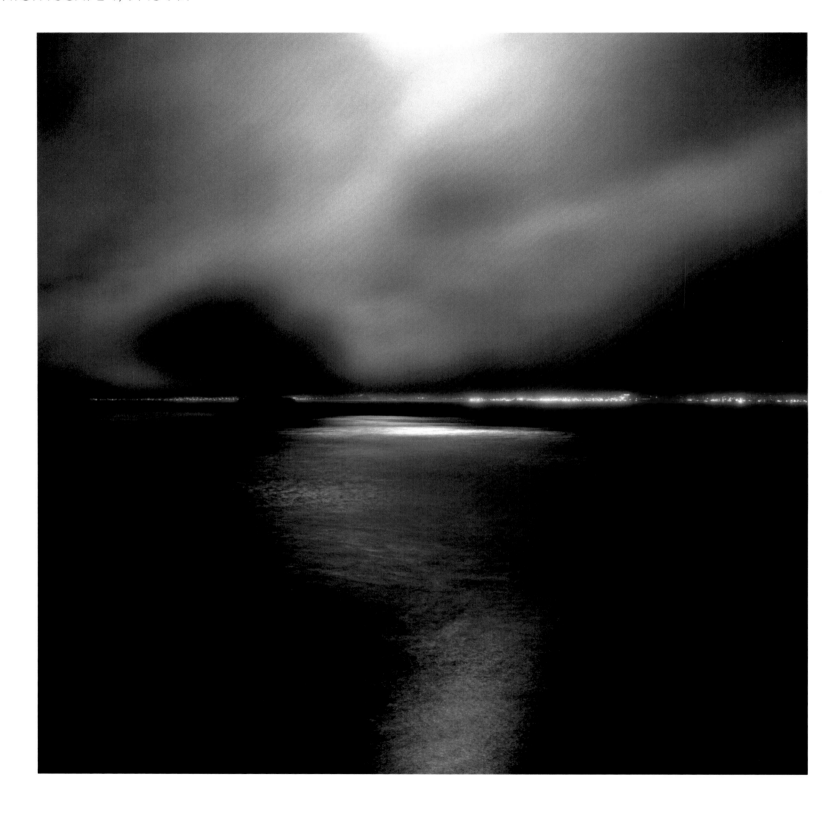

Writer
Patricia Weaver Francisco

LIGHT, THE HORIZON

The necklace of light across the bay, sleek boats that come
and go, for others, others. They are clinking glasses, they are
shining — women move in and out of rooms, apricot and leather,
white wicker on the wide porch. They wake to wind lifting the
veil, clothes draped over a yellow chair, quiet morning rooms,
buttered toast and figs, someone gathering flowers, someone
murmuring, a long-haired girl, long-legged and at ease, crossing
to kiss the patriarch, no deception slowing her gait, inclusion
filtering her gaze, the patriarch's kind and settled face, spectacles
burnished with cunning, and with love.

The watery world darkens into what cannot be accounted for,
what can never be crossed — no coin sufficient, no ferryman able.
The horizon eludes me. There is only the harsh burn of industry
and a harboring desire. *Come, come, come!* The sirens sing from
winter's dry dock. Someone is lying. There's broken glass in the
underbrush, and the necklace of light always beckoning, always
true.

Writer
Joyce Sutphen

LIGHTS ON THE HORIZON

The moment he took the picture,
he knew it was the one he wanted —

the lights were like windows
on a train coming into Chicago

and Sister Carrie was there, gazing
into the darkness. Nothing

had ever happened. Or the lights
were the lights on another train —

the one that sank to the bottom
of Fingerbone Lake (I often think

of that train, imagining the lamps
lit and golden under the water —

some Atlantis, some strand of light
on the dark throat of night).

Photographer
Anna Hurtig

PONDSKATER

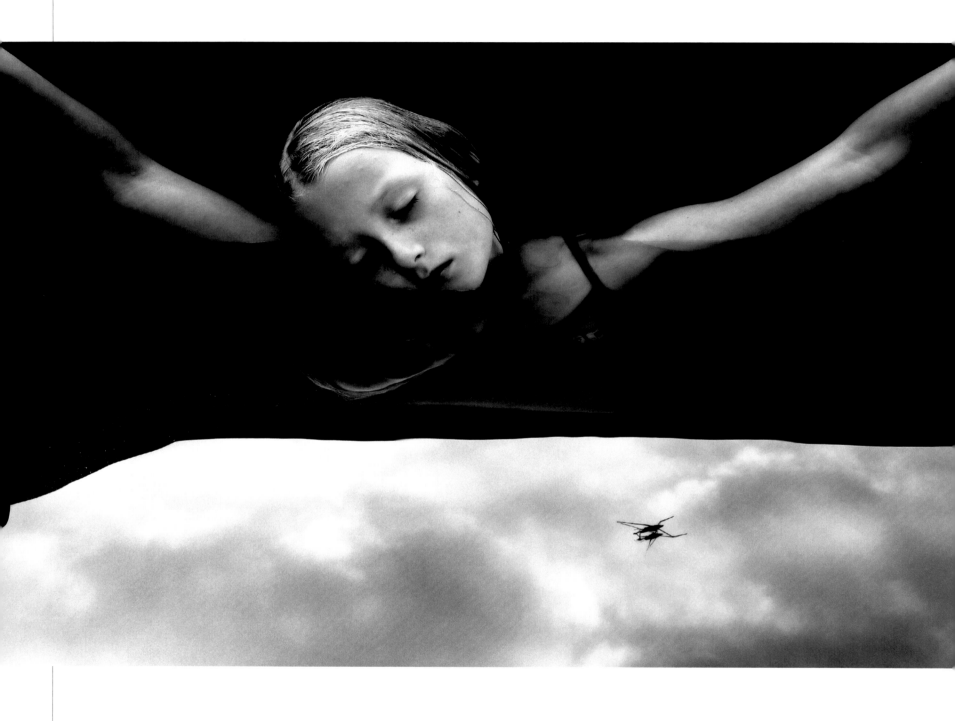

Photographer
Anna Hurtig

Writer
Jacqueline Kolosov

EMERGENCE

Not to be confused with the descent —
a trap-doored fall through water
breath a wool cloak, an egg sac on the tongue,
the fishes' medallion sky against hips, thighs, ankles —

Not a souvenir of resurrection
and less a memory with lungs and a plummy heart
than a picture
behind the eye, the swollen blue of irises in rain

Not overripe fruit — a cold chalice of bruised grapes —
or St. Petersburg after the thaw, a woman in black lace
crushed beneath a train, her's a sorrow
redolent of coal, sweat, salt
from a forgotten sea

Not grief's dusty tortoise. No,
not this lesson in endurance, or the girl
with hazelnut eyes, and skin so fair
she reminded you of beech trees seen by moonlight.
Remember? The girl who refused
every morsel, who became sculptural, pure
pain, all edges, perpetual

Not your mother's voice
you wish you could follow
all the way back
to yesterday or into tomorrow
 Not this, but
You now, arms outstretched before sun-bleached rock:
open your eyes, behold
the absence of shadows and a sky rinsed clean.

Writer
Milissa Link

UNTITLED

I had my nose in a book. Every day. All summer.

Sprawled on a terrycloth beach towel near the deep end of the pool, a paperback shading my face, I read. Older kids played poker and snuck Winstons under the snack bar's overhang. Too young to drive — but too old to be driven — we all rode Stingrays to the pool. Our parents were on the golf course, most of them lingering over G & Ts at the 19th-Tee Bar. It was probably a blessing in disguise that, once our legs were long enough, we were expected to get around by bike.

I read classics poolside: Dickens (I related to those orphan themes); Louisa May Alcott (hardship in the midst of plenty, with high moral overtones, played well with me); The Greeks (tragedy and myth had their appeal).

On a particularly muggy day, a bit before noon, I put down my book. I didn't glance at the kids at the snack bar who were too cool to swim. Half-hidden in the shade, a boy yelled, "Syph!" as one of his friends slapped down a full flush.

The Olympic-size pool was as blue as the Mediterranean, though it was just in St. Paul. I shimmied on my bottom toward the nubby concrete edge. I didn't care if my Speedo pilled up. None of those bare-chested boys, cussing over cards, were going to let their eyes wander up my skinny legs, anyway.

I leaned forward, ready for liquid relief. Reflected there, on the surface, I saw a tan face the color of a young pomegranate. The skin was bright and clear. Closing my eyes, I dove. I couldn't wait to be her, just as she was now. Before she became the object of someone else's desire, stopped reading and lost her color, her vigor, and pined away.

Photographer
Marc Ullom

UNTITLED

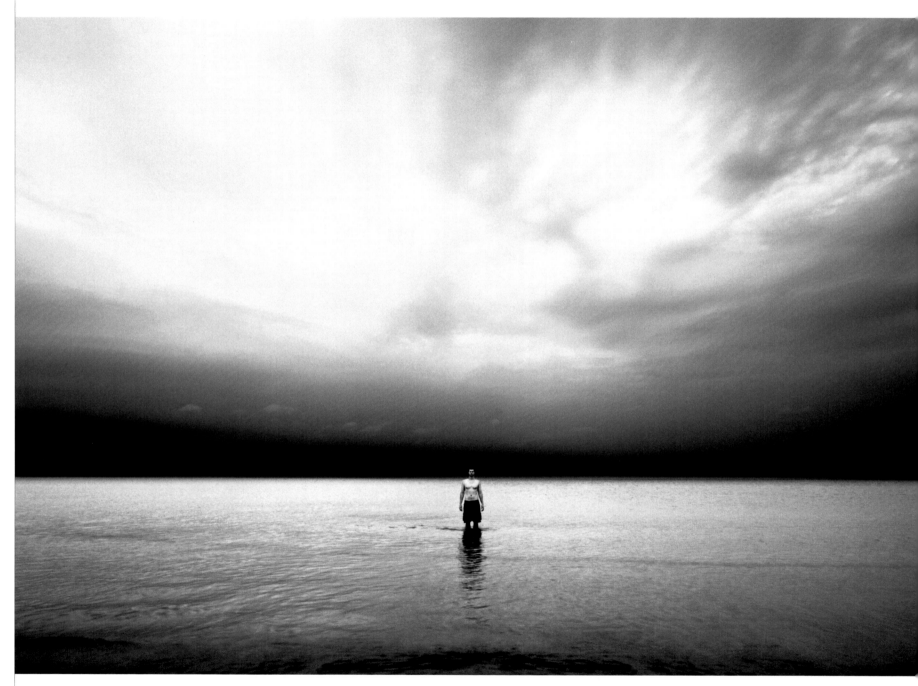

Writer
Rigoberto González

TETHER

The ocean along the coast of Brazil was deceptively calm. And since it was clear and still as a swimming pool, I decided to do laps, moving back and forth in the warm water. The exercise so effortless, so smooth, that when I lifted my head from the surface, I discovered that all that time I had been floating away. I was lost in the open sea.

Suddenly, the sky darkened. Suddenly, the ocean grew opaque, and when I swallowed a mouthful of water in my panic, it felt as if I had eaten mud.

Death by drowning, I imagined, was going to hurt. I saw my body filling up with water and swelling like a weather balloon, except that instead of a buoy, my body would harden into lead and sink to the ocean floor.

I surrendered to my fate, letting the tide carry me off like litter, the drowned rat in the sewage pipe flushed out. And in that stillness, the laughter of children playing on the beach... How they had chuckled at my swimming trunks, baggy and bulky. How they had stayed close to their mother, a large and beautiful woman in pink, like a majestic creature of the sea. How I had envied that safety — myself, motherless for decades, roaming the earth unwatched and unseen.

Or so I thought, until the miracle. Somehow I drifted back to the shore. When my toes touched the sand, I began to cry, returning to the ocean the salt that I had swallowed. I wasn't sure which mother had taken me in: my own, the one in pink, or Yemanjá, the great goddess of the ocean. Or maybe all three were one and the same.

Writer
Matthew Specktor

NOTHING WITHOUT FLAWS

Once, you thought you could control it. Wrinkle your shoulders, your forehead, your thoughts. See how small you are? How your eyes, like weather, shrink to fit within their frame yet won't give up their war with infinity? Look before you. There's a person over here, waving. Look above. There's...what? A whirlwind? A storm? Behind you rises a wave, but you won't see it, too smart to take in the thing that will destroy you. Perhaps you are smitten with its beauty, or your own. Perhaps you imagine it will stop to admire your pecs and your shoulders, as I do, as anyone would, really. It's too easy to criticize the light, and too difficult to describe its action. I never tire of it, though. Do you? We imagine the world is here for us to look at. Then, we choose our positions. Lyrical, religious, agnostic, urban. *I'm a city boy, I've never seen anything like it. My, what a view.* The error is to imagine we know something, that we can say *peach-pale, look at those clouds, my God, it's cold out here.* But it's not. The chill is in your bones, and not at that...thing that swirls around your knees. Look at it though. Try to give it a name. It's slate-like, it's steely, it's the color of a humpback whale. It's all of these things, or none of them. And yet, there you are. Impervious. Stubborn. Asserting yourself as the one thing wrong with a landscape that's nothing without flaws. And that will let you remain there, until it's time to take you home.

Photographer
Susan kae Grant

SHE'S GRASPING
HER BEHAVIOR

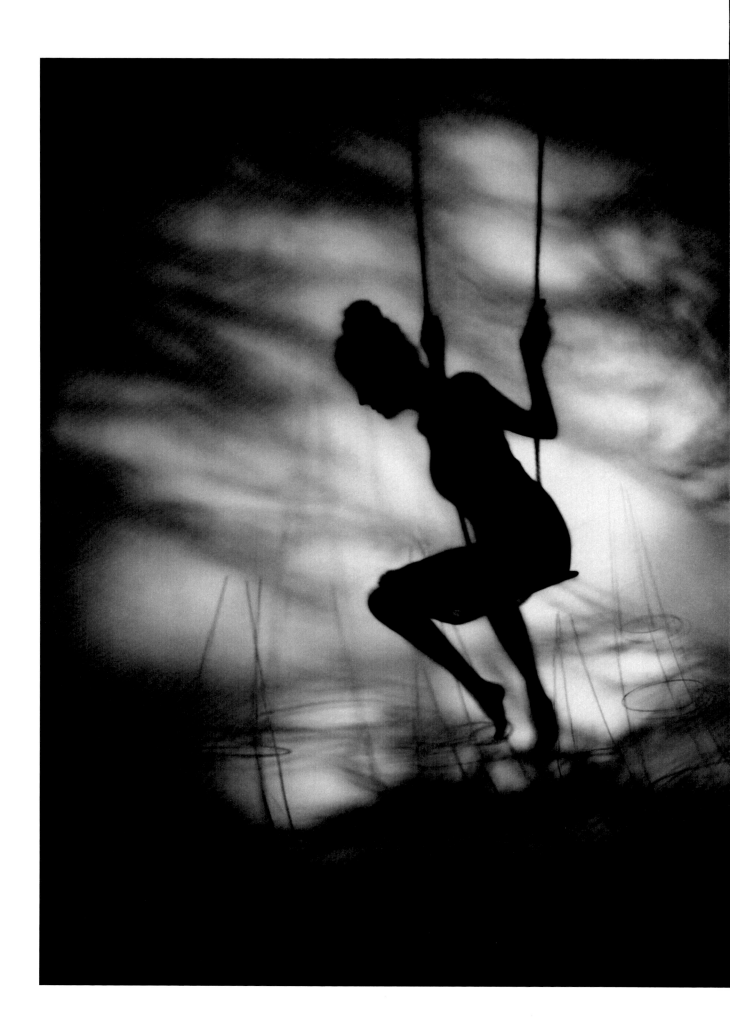

Photographer
Susan kae Grant

Writer
Natalie Vestin

WHAT NEVER HAPPENED

Long ago, I swung on a swing
and let my head fall below my feet
and let my hair trace the swamp
we called a pond and pushed
my legs into the sky.

I let the torn hem of my skirt fall
away,
and my friend rolled her eyes
and laughed.

Years later, the swamp disappears, sinks back
into the mud and dry rushes, the ghost of movement
on a swing that has crumbled,
and the frogs have no words to claim
it was ever real.

If it were never real, then I suppose
there was no thick fog made of swamp gas,
like closing your eyes
and dreaming of lavender.

I suppose there was no ghost wearing white, staring
from the far bank, and there was no water sky-deep,
no girl lighting a fire under a tree,
no girl eating pizza, licking grease
from her hands — no boy
she'd said I could meet, no laughing through the dark
to swing away from the land,
over water that turned to a pit of stars.

It never happened, the running and falling and rolling,
the clouds that settled over the pond, locked in
by a fence we cut our legs climbing—
no running, scraped and bleeding,
shedding our skins for a swim.

Writer
Charles Taliaferro

2,400 YEARS AND COUNTING

For 2,400 years philosophers have debated the nature of the infinite. Today, many (but not all) philosophers agree with Aristotle's belief that there can be potential infinites — someone could begin counting today (1, 2, 3...) and (assuming everlasting youth), never come to an end. Aristotle thought there could be no actual, complete infinites; there could be no reaching the greatest possible number. We sometimes forget, though, that whether or not there are actual or even potential infinites, these very ideas come from something that we might well say is of infinite value: a singular being who can think, act, and love.

Photographer
Nan Brown

SWIMMING HOLE

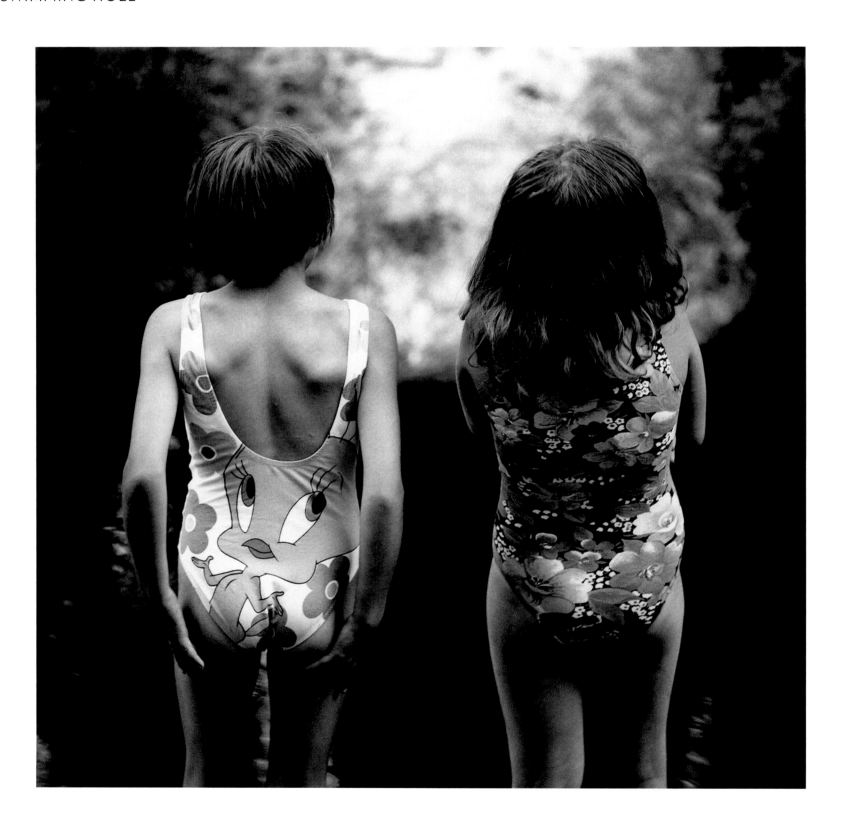

Writer
Lisa Hartmann

ONE STEP

Go.
Step over the threshold.
Cross the
invisible line.
A whole world
awaits you on the
other side.

Don't squander this life with
grown-up worries.
Open the door to your
uncertainty
and let innocence
back in.

Take the first step.
Brave or
tentative,
it doesn't matter.
Take one step.
Just one.

Writer
Joshua Wilkes

UNTITLED

Janine's house is a little cabin in the woods next to a pond, so it wasn't a *pool party* no matter what the invitation said, or what Janine said in school. *I'm having a pool party for my birthday and everyone's invited,* meaning just girls of course, all the girls in our class.

Who invites everyone? A: A girl with a mom who makes her or B: a girl with no friends?

Beth says, *Oh, I pick B. Her dad drinks and is some kind of retard! So fail!*

(Beth says two things a lot and one is A, and one is B, and the stupid funny one is always B, and she says *Oh, I pick B. Fail!* I think it's from TV. Dad calls Beth *the young sophisticate* and Mom says, *Karl, she'll grow out of it, they all do.*)

Janine's house is at the end of Hatz Road, which is paved until it's gravel and then there's the pond. It smells fishy and like worms, which Janine smells like, too. The water is green and hairy.

The card says: *Wear your suits under your party clothes!!!* so first we sit outside in folding chairs, sing, eat cake, and all the time my suit is scrunching up, but of course: *Please ask before going in to use the bathroom.* There's a dock that goes into the water and a float in the middle of the pond. We leave our clothes on the picnic table. No girl has a two-piece, only Janine.

The screen door bangs and Janine's Dad runs out. Like, he's hairy and has a red face. He runs through the yard, past me and Beth and everyone, down to the end of the dock, jumps into the air and shouts, *Cannonball!* The green water crashes up.

Photographer
Kirsten Hoving

EARTH'S ATMOSPHERE

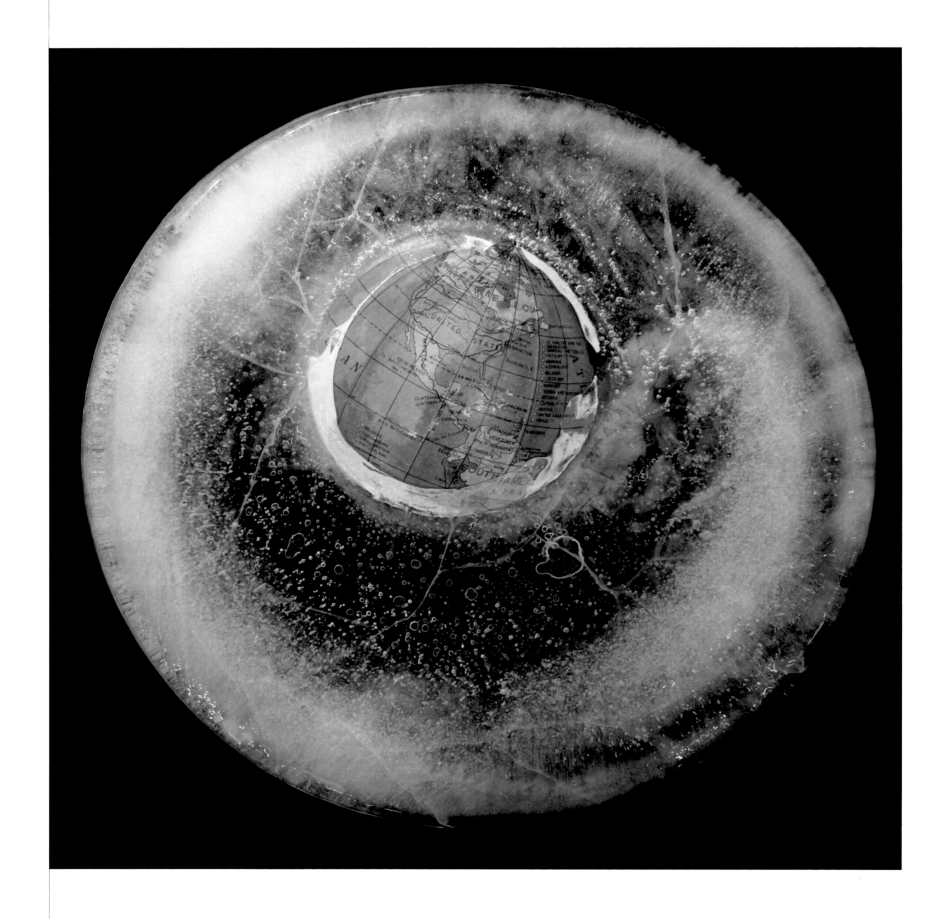

Writer
Wendy Amundson

THE COLD WAR, UNFROZEN

The Cold War didn't scare me as a child. Sure, I felt moments of uneasiness when learning to "duck and cover" in the event of nuclear attack. Would my tiny school desk really protect me? Should our family have a bomb shelter, too, like the ones in *Life* magazine? But they were never more than fleeting thoughts, vanishing at the sound of my teacher's voice, calling us back from under our desks.

The Cold War was the last of the polite wars, played by rules that no one ever published, but somehow everyone knew: You don't bomb us and we won't bomb you, but we can and we will. With both sides resolutely standing their ground, the Cold War felt less like a threat and more like an icy cocoon, protecting us from our baser selves.

When the Cold War ended we thought peace was the butterfly that would emerge from the cocoon. But it did not. Our baser selves were still inside, just waiting to get out.

Writer
Joel Kaj Jensen

UNTITLED

Humans privilege the geometric. We have been imagining edges at least since the appearance of mathematics in ancient Egypt. An early taxation scheme apportioned dues according to the extent of the Nile's yearly flooding. Well-flooded land being valuable, geometricians set to the task of determining the inundation's height and surface area. Flooded areas were superimposed with approximate geometric shapes — rectangles, trapezoids, parallelograms, for which area was easily calculated. The water's edge, not really an edge at all, was tamed with imaginary shapes to fill pharaonic coffers.

How unavoidable such abstraction is. Perhaps we can't help ourselves, perhaps lines and edges are more comforting than fractious bumps and curves. We still demand of water a boundary, and thus, promulgate geometries. An edge is duality: inside against outside, familiar against other, sharply delineated, separated. Standing at the edge, we imagine a known quantity to satisfy us: perpetual definition, permanence even without our watchful gaze. But this is illusion. Any edge is perpetually made, unmade, assembling, dissembling; we stand at a demarcation of our own devising, looking *outward*. Why conjure such boundaries? To convince ourselves of our own geometry? To maintain our illusions of an outside, and finally, a horizon for which to imagine a beyond?

Aristotle, nursemaid to logic, spent afternoons gazing at the sea. He trained his eye on the horizon's edge. Ships on the horizon became visible first by the tip of the mast. Drawing nearer, one could see the sail, then finally the hull, triremes and biremes returning to port. The horizon, it seems, was not an edge at all, but a continuous and indefinite curve.

Despite the limitation of our vision, the world resists our definition, self and other, known and chaotic. We impose our boundaries, yet, the world is round.

Photographer
Sarah Rust Sampedro

MAY 12; UNTITLED

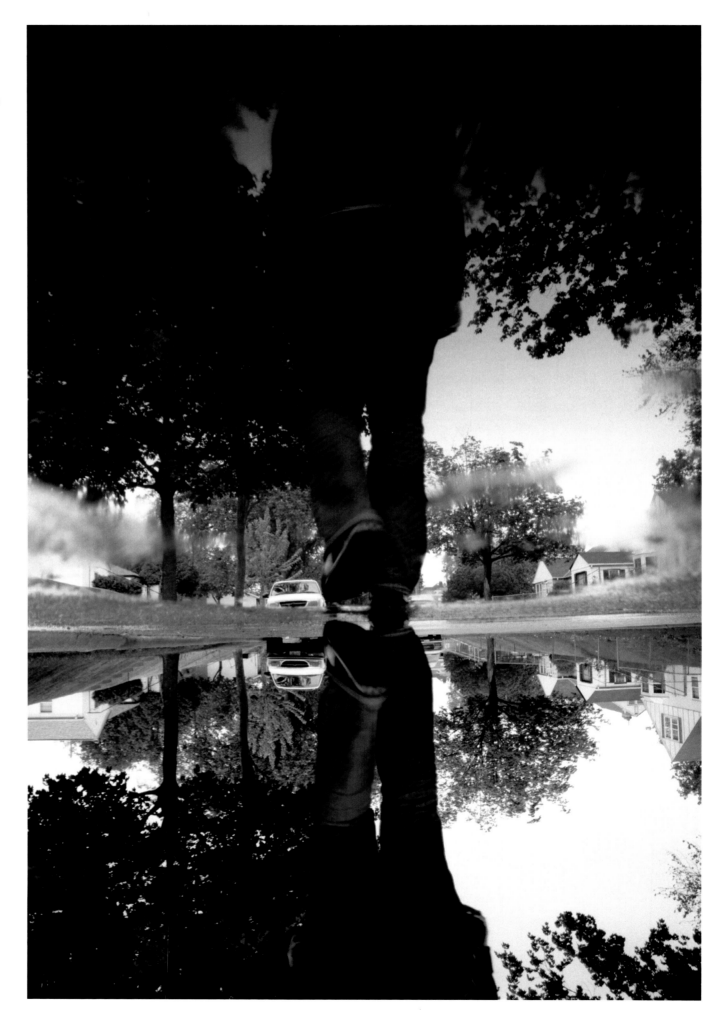

Writer
Kyoko Mori

THE OTHER WOMAN

In my baggy jeans and denim jacket, I squint at the produce his wife brings up to the register at the organic grocery store near campus. Lines appear on her forehead as she is forced to tell me, *arugula, Asian pears, mission figs*. Almost my mother's age, she believes all small-town girls are stupid. She has no idea I am only pretending ignorance.

Her dark eyes have stared at every inch of me from the photograph on her husband's desk. If they had children, she would not make salads with fruits in them. He is a simple man from a dairy farm like the one our family lost. He never imagined teaching history at a college and falling in love with a girl who dropped out for lack of funds.

Last night, I dreamed I was wearing his wife's red dress — the one from the photograph. I woke up remembering the Japanese carp my brother once kept in our backyard and the Halloween story I wrote in high school about the prettiest carp, the red one, turning into a girl and walking out of the pond. On All Hallows' Morning, the carp-girl woke up in the farmhouse bed and visited the pond with breadcrumbs for the farmer's daughter, who rose to the water's surface, opening and closing her mouth in vain.

This morning, the street in front of their house is wet with rain. The world is a murky, upside-down picture. Behind the wheel of his car, he doesn't yet know he is traveling toward me. He has lived too long with a woman who can give him nothing. It's my turn now to breathe the air. When I step out of the water, my foot will break the false mirror and everything in it.

Writer
Cynthia Truitt Lynch

NOT YET BARE

Today, after drop off,
I walk quietly away from his school,
that place I am to leave him for a few hours
while his education bathes him in knowledge.
The sidewalk is my meditation in a path of sorrow.
He's such a big boy now.
I wind my way back home,
a canopy of trees stand erect,
not yet naked,
opening up to the bareness of winter.

Photographer
Alec Johnson

CHANGE

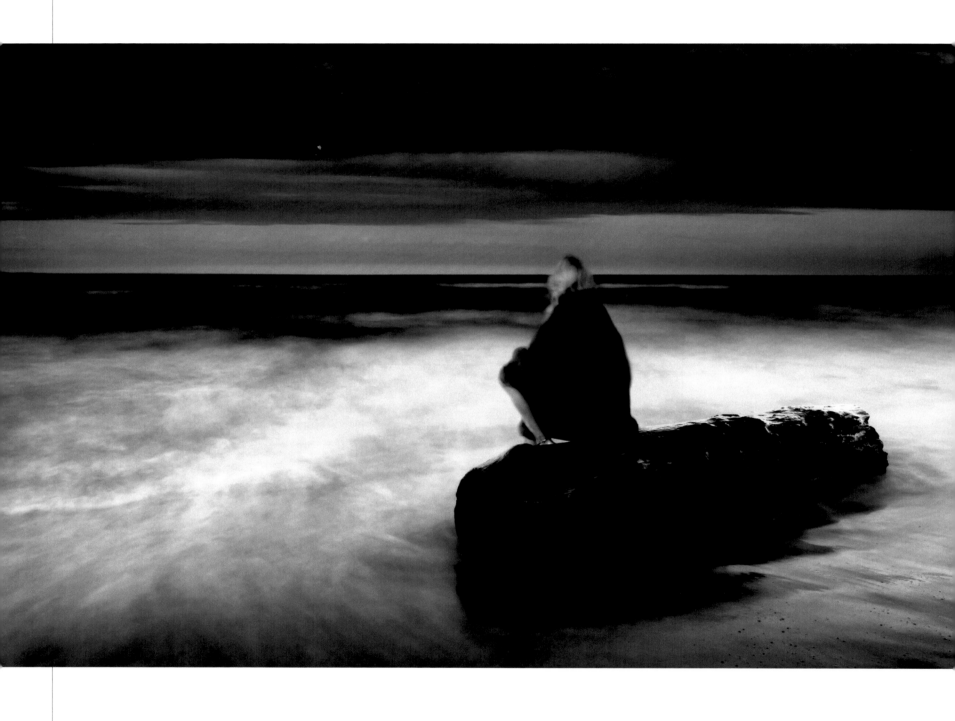

Photographer
Alec Johnson

Writer
Blair Braverman

Writer
Jaimee Wriston Colbert

THE DROWNED GIRL'S HOUSE

There's a hymn in Norway, heaven-bound, borne from a thousand white-throated churches: *Thank you, God, or whatever you are.* And I'm telling you, I know that song. I lived a year in the shadow of such a church, in Sand, population 53, which included two big-beard mushers and a farmer with forty white goats and a fisherman, Arild, who hung his cod like stockings in the Arctic summer sun.

There were twelve children in pointy caps and six mothers with and without men, and by the fjord, a bulging deep-brown ghost house, dead since the War, with three planks gone from the kitchen floor and a desk full of letters, and a fur coat of wolf or wolverine curled in the attic like a thing asleep. A girl drowned there, people said, fell through the ice on a spring day while everyone else rushed to shore to cheer the Russian ships goodbye. After they found her, no one came back.

While the town went to church, I went to the house, ducking under the tunnel of Arild's cod. And while voices spread singing in the valley, I stepped up the stairs one by two, and lifted letters from the desk, words written in a language nobody remembered.

Once I thanked the letter writer aloud, as I waited alone in the wooden room, but suddenly the dust was too full of ears and I never spoke in the house again. And once I lifted the coat and shook it, poured it over my shoulders and expected something. But the folds stayed stiff around me, the plush of the fur too much like frost and the animal still breathing there, the two of us hunched in the frame of the attic window, and whatever you were, I threw you to the ground.

FIN

She talks about the pull of the deep that is inside us all, a fetal need to return to the sea. Here it is, she says, proof of reverse evolution: how once she loved a man who turned into a fish, growing fat and translucent, his short little legs drawing up into his enormous belly, curving in, then out again like fins. His skin became scales, a silvery shimmering in the damp new morning. When she woke up, their bed was wet and she turned over just in time to see him float out the window, flip on his side — his flounder eye shining bright as a new penny — twitch of his tailfin and he was gone.

Writer

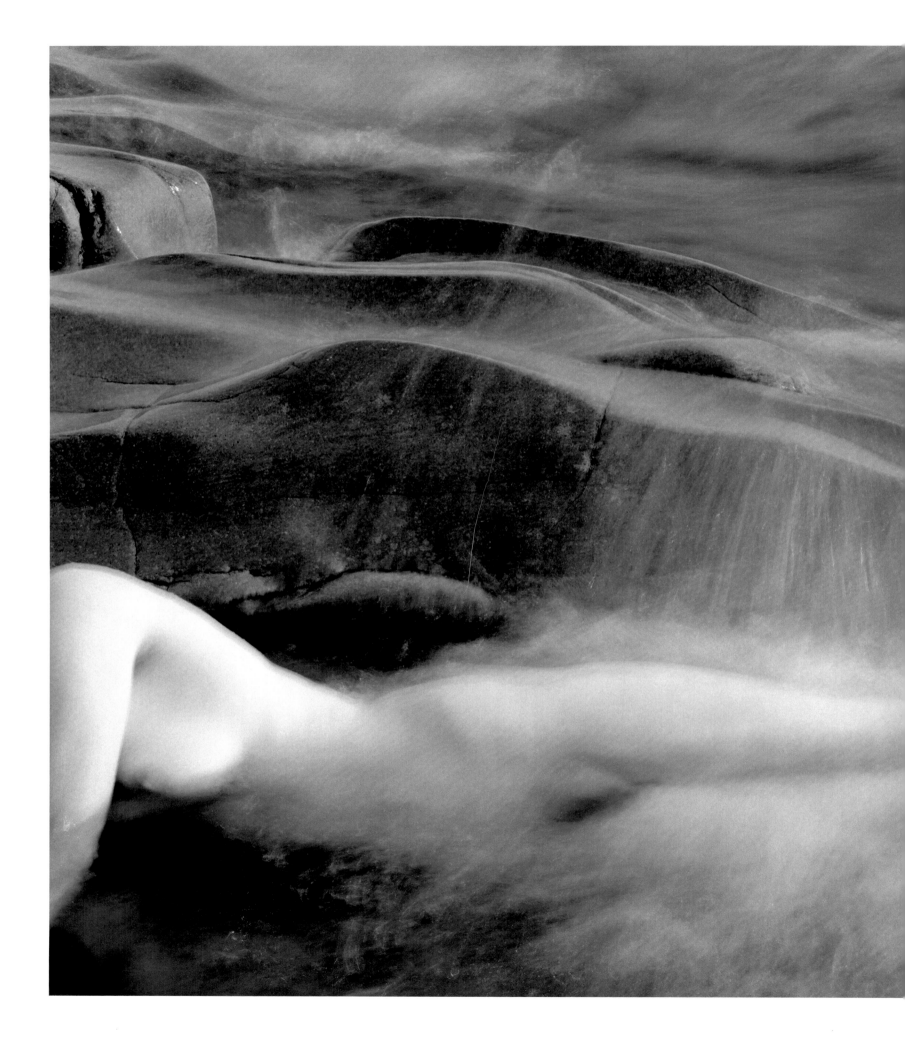

A VOICE WITHIN – THE LAKE SUPERIOR NUDES,
PLATE 75, ARMOUR ISLAND, ONTARIO, 1998

MOBY, US, TRIP

Once I set out to fish and thought nothing of the hook and net
the treachery of bait. I said teach me to fish and I will feed you.
Now that I have been baited and learned the nuance of evasion, let me
live as a fish and I will love you. No more reckless wandering on
dry earth, no more stones in my useless feet, just the waves
dressing, the sand caressing my legless life bundled into nets adrift.
The foam wine sea brings plankton confection, screens moving
pictures on water walls of surfers flinging their tonguefish boards to bounce
and carry home my wayward thoughts on seaweed scrolls,
singing siren songs that pierce their threnody through to you,
enthroned prince-like, dipping clumsy royal feet
at pier's edge, thinking longingly of that day
I sank, a particle of rusted hulk, to savage the sandy shoals with sharp dorsal beatings,
no longer littering your court with my wilted roses. You now, my Ahab,
ravish me with honed harpoons and I will sound the white depths — impenetrable
by any man so human as you.

Writer
Julia Klatt Singer

WITHOUT STARS, DISASTER

We've been without them for over a week, swimming in a fog so firmly set on staying, we wonder
if we should invite it in for a glass of Claret, a fine, aged cheese, olives & bitter chocolates.

It has you thinking about the Old Testament. Pillars of Smoke, Trees of Life, wives turned to salt,
charming serpents, little boys with slings, fighting giants. Love poems, psalms of sorrow & despair

& praise, prophets being fed by ravens. I close my eyes & pretend I am Saul, feel the gravel
of the road, nibble my way home. It is dusk, the fog is slumbering, thick upon the grass. Into the garden

we go, without stars to guide us, we follow the scent of thyme, the piano drops of melting snow. You
a crimson bird, darting from branch to branch & I, a solitary nude, so still you mistake me for stone.

Photographer
Daniel Colavito

DANNY IN THE RIVER

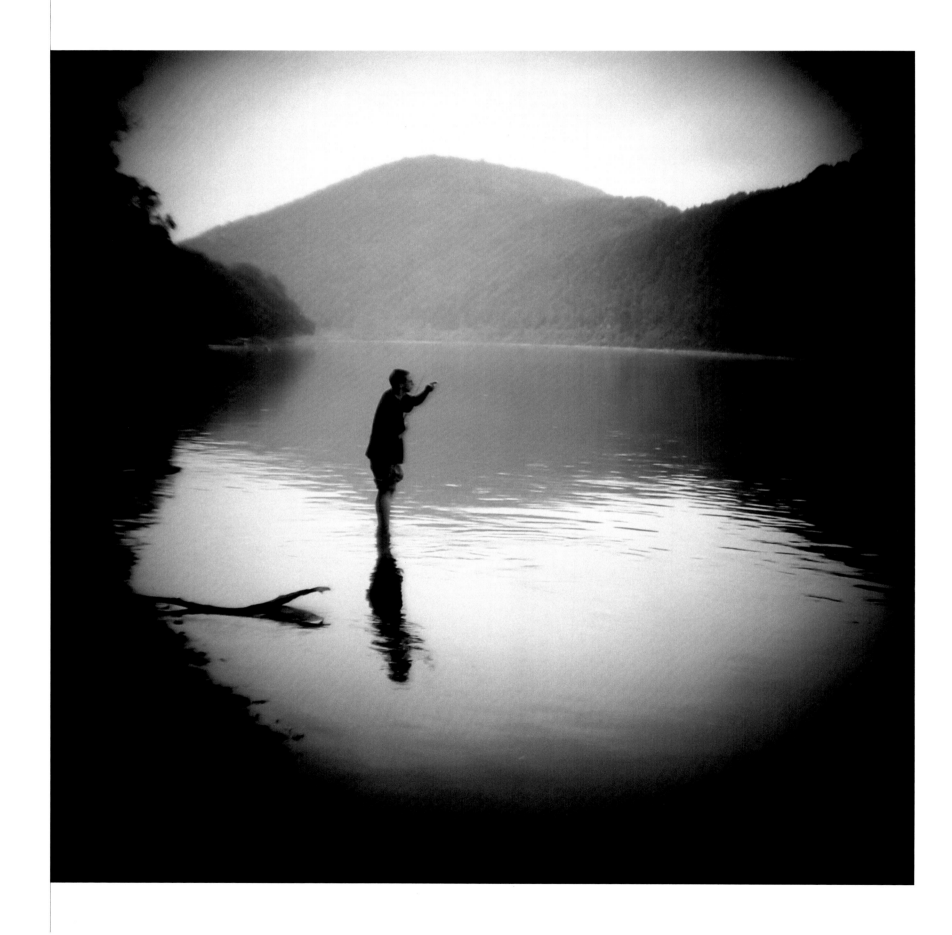

Writer
Geoff Herbach

NO FISH

It's you I want to hook in your mouth. Fish are not people.
It's you. It's you I want to pull onto the shore and club and fillet
and eat.

This is love. This is what I have. This is everything.

This is when passions are put into the big iron pan and are fried
over a teepee fire under tree and star, no suburban street going
nowhere with Styrofoam house, an absence of cul-de-sac that
might stop the flow of our blood. All of that is gone.

Drink. Water.

No cul-de-sac stops what I want to do with the entirety of my
animal self — I want you to struggle, but know your struggle is
unnatural, but you can't help it, but you wish to be overcome,
because you sense the absence of the essential, because I will
show you the path of light, of real freedom, of nature, and when
you get tired of being that which you are not (manager of bank
tellers, hair-conditioned, high-heeled shoes), you will slide across
the sand barefoot and I will take the hook from your mouth and
I will cut out your false heart with my knife and I will show you
the real one beating beside it, and then I will devour you inch-by-
inch, from heel to calf to thigh to hip to angel's wing to lotus ear
and finally, your wounded lips, and you will be healed and you
and me will be the same animal.

This is just what I mean.

It's you I want to hook in your mouth, no fish.

Writer
Susan Jacobs

RETURN

Yes, yes
that's what I always wanted —
to return
to the body, where I was born,
like a fish
eager
in the river of its birth.

Photographer
Douglas Frierott

GABRIEL

Writer
Jim Heynen

GREETING THE OCEAN

The ocean? The grown-ups had told him about it. Bigger than anything he'd ever seen, they said. Bigger than a cornfield is long. Bigger than a church steeple is high.

The boy figured it was one of those grown-up whoppers. Like ghosts. Or Santa Claus. Or Mesopotamia.

But then they packed the van with potato chips and pillows and throw-away juice boxes, enough of everything for three-days travel to reach the ocean.

The first long day was waves of corn and bean fields, but the second day brought mountains that rose from the yellow sagebrush, coming closer and growing taller. A winding road took them so scary high that he closed his eyes and pretended to sleep. That night, he dreamt of falling off a mountain, but not of the ocean.

The next day, the boy kept his eyes peeled, but the ocean didn't creep toward them the way the mountains had. It happened cruising down a smooth road while he was on the last bag of potato chips and last box of juice. A field of sand just appeared, and a little farther, there it was: the ocean!

The grown-ups turned him loose, and he ran straight for it. As he got closer, there was something that pictures didn't show and that the grown-ups didn't say. Nobody and nothing had told him how loud the ocean was, that it could hiss and shout, that it could whisper and roar. The ocean never shut up. At first, the voice of the ocean scared him, but since he'd come this far, he kept running at it. *Says who?* he shouted, and greeted the ocean with a hefty splash. That night, he did not dream of the ocean's chatter. He dreamt of silence and endless rows of corn.

Writer
Kevin Winge

WHITE PRIVILEGE

Because you are a child — carefree, joyous, delighting in a world made just for you — you have no way of recognizing the gift of your good fortune.

You can play in the sea. And when you return home, your clothes will be washed. And you will be bathed. And you will have clean water to drink.

Today and tomorrow, day after day, without question.

You will never wonder where your water comes from. Or if it's safe to drink. Because you are white, and you are male, which means you are lucky.

I wish you a long life, dear child, and continued blessings. But more, that you grow to be a young man who recognizes the gift of his good fortune.

Photographer
Elizabeth Siegfried

OFF SEASON 2

Writer
Rosemary Ann Davis

WHAT I BROUGHT HOME FROM SAN FRANCISCO

I.
Streets named after planets:
Mars, Saturn, Uranus. Looking
down from Twin Peaks — a
city on fire. Erotic passion,
contagious love, funeral pyres,
and the desire to be free,
to go home.

II.
Desperation, panic,
silence in eyes too young
for resignation. Abandonment.
The brave front. Humor
rising like a wave to cover the
mounting horror. Resolve.
Endurance. Then finally, rage.

III.
Harvey Milk's voice from an
empty stage. Rides in the back
of pickup trucks. A Proposition 13
button, Pride program from 1978,
leftovers from brunch.
Laughs from *Saturday Night Live*,
drugs in foil wrappers. Giant
ferns, retro '50s drapes, crumbs left
on my living room table after
the party was done.

IV.
One cardboard lamp,
the drawing done in 1975.
Three towels (two black-and-white,
the other for the beach),
his socks, the grey ones,
both bathrobes, two books:
Living with AIDS and *A Day in the Life of America*,
and the postcards (found in
a dresser drawer) from our
long years of separation.

V.
The smell, the lingering presence
of familiar people,
quick wit, sarcasm, a few
discussions about psychology,
Paul's red hair, John's, medium-brown and shaggy,
white teeth, toned bodies,
the laughs, the overnights, the wine.
I would have taken the cat,
Lydia, but she could not be found.

VI.
The mangled order
of your words, careful to
explain dreaded details.
Independence left behind.
Dementia. Blindness. Waiting
for your sanity to return. Later,
organs giving up and shutting down.

VII.
Black dress, with roses.

Writer
Jennifer Gardner

THE OFF SEASON

The trees have dropped. Silhouettes stand without color, delicate wooden lace veiling the view. This season has been edited, as it is every year. Speak about what is missing. See only what is left: fallen foliage. I want to swim under the leaves, look up at the patterned decay, wrap myself in polar fleece and press my face against the slats of a summer lounge, breathe in the hibernation of the lake, hold the quiet in my belly. I want to sleep like the valley sleeps, then wake slowly in April, serve breakfast in June. It doesn't work like that. I'm here to skim the pool and act as if vacation never ends.

Photographer
Gail Murton

SELF-PORTRAIT

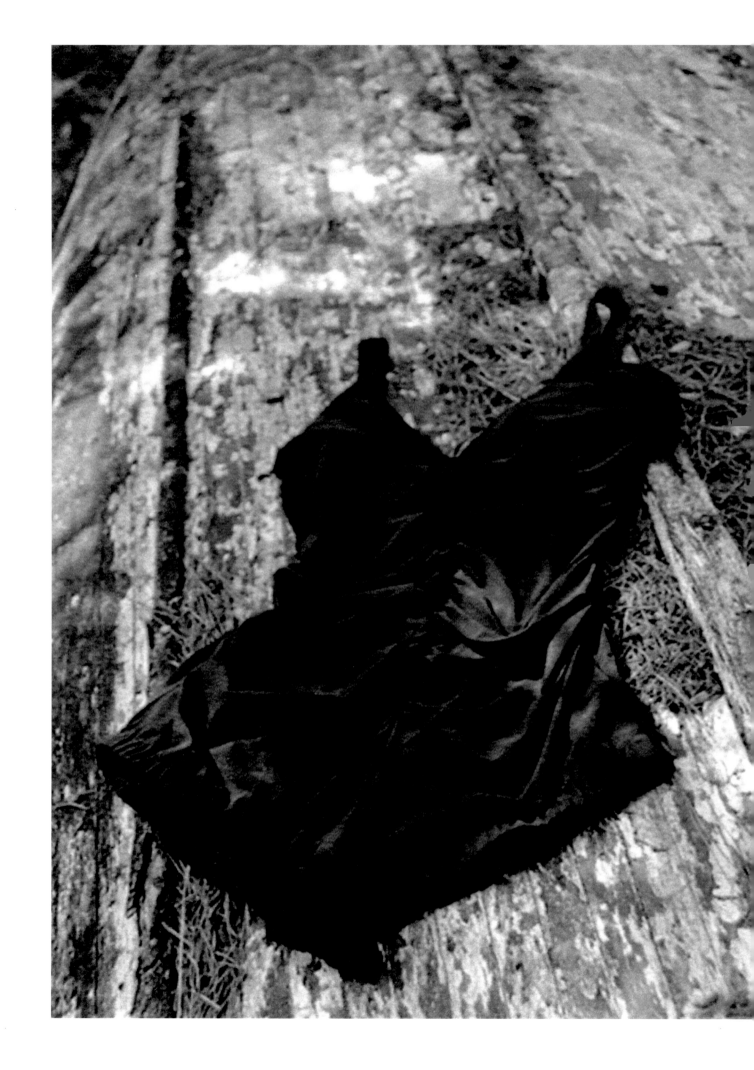

Writer
Mieke Eerkens

THE SUITOR

She had watched other girls show up at the burger joint downtown, hair damp, cheeks flushed, in that baking July summer. They squeezed into red booths with their guys and the guys ordered them milkshakes that never seemed to go to their tanned and toned midriffs. She had watched them from adjacent booths with her besties, Anne and Sue Ellen, trying to sit erect so her thighs wouldn't spread too much on the vinyl. He had approached her one afternoon in the parking lot. She recognized him as having graduated the year before. He was nineteen and had a real job working at the steel mill. He had dirt under his fingernails, but a disarming lopsided smile, and boys didn't often talk to her. He asked if she wanted to go swimming with him and his friend the next day. Later that evening, she was so nervous, she sweat dark spots into the armpits of her shirt as she walked along the racks of swimsuits — the shop about to close. Running out of time, she hastily selected the one-piece for its camouflaging folds and turned self-consciously in front of the dressing-room mirror. When she arrived at the swimming hole the next day, he was alone. He took her to a spot that he said had the best swimming. They had to push through brush to get there, but he held the branches aside, took her hand to lead her under the thorny limbs, and she felt like a real lady. He spread a blanket out on the ground. She set her bag down then stood awkwardly, weight shifted to one leg. "So…should we swim?" she asked. "Yeah, definitely. In a minute," he said. He patted the blanket next to him. "Why don't you sit down first?"

Writer
Susana S. Martins

WE WHO HAVE NO GODS

I didn't have the heart to tell her: there is no heaven, there is no God. I was sure of it now just looking at her, stripped bare and shivering on the rotted planks by the water's edge.

So I said nothing, and she swayed a little, the wind rippling through her as though she were made of water. She wanted to cover herself; I know she did, the way her arms twitched. But she willed herself to be still.

"Look," she said, even though I was already looking at the Y-shaped channel through her flesh, the vertical scar that split her chest and then branched off in both directions toward her jutting hipbones.

"Look," she said, and I knew she meant she would not let them cut her again. She was done with placing her faith in men. She wanted me to say that there must be someone or something else she could believe in.

But I, I was only a man — my gifts limited. I put one hand on her chest with my thumb resting lightly over her heart. A moment passed. Then, drawing back my arm, I began to strip so that she could look and see me standing there — only me — alone in my skin, alone but with her, the way we all live, we who have no gods, we who are naked, we who stand at the water's edge.

THE KISS

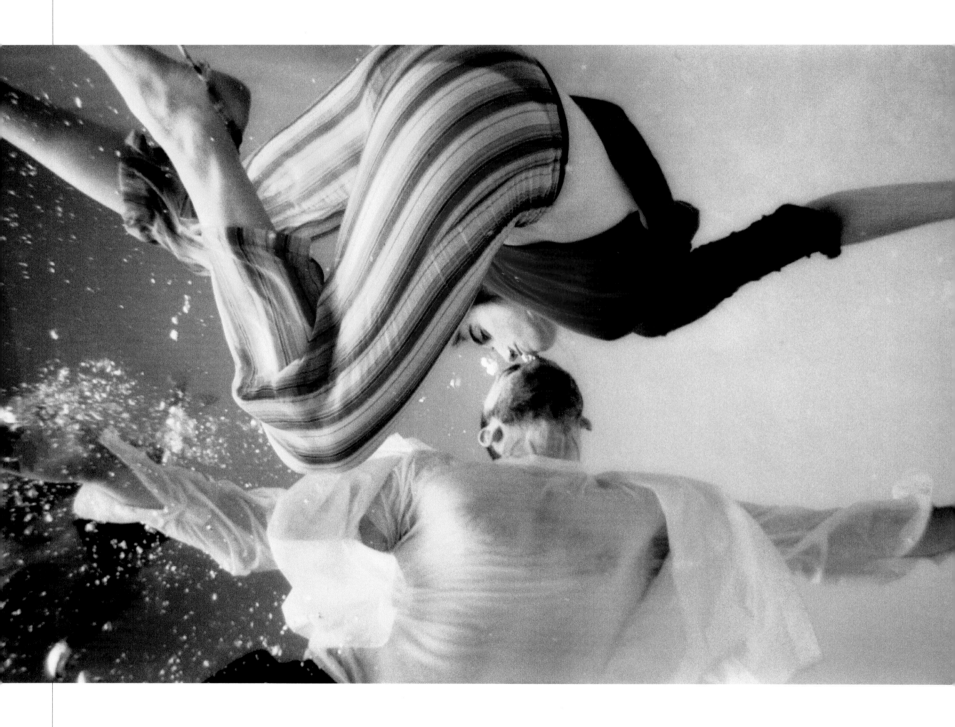

Writer
Justin Maxwell

OF RECKLESSNESS AND WATER

It is hard to kiss, because kisses only happen underwater. All the wetness is a panacea, and we have been so sick, drowning in fashion and electricity. How I love you. It is good to be so upside down, under water, where perspective is always forced. Who *is* right-side up? Surely not me, and you are far too lucky. It is good to be upside down, just so, between the coming-and-going motions — breathless under water, kicking slowly, oxygen bubbles ascending sideways in disorientation. Oh, the aeration of a kiss. Oh, the ever-rising tide of the body, the layered meanings of salt water: our saline hopes, our secret flavors. Our combined failure to tread water will go unmentioned, unlike the filmic reveal — wet clothing gone translucent against the skin, the slime of a fish, the striped oil slick of color — narrative looming and stupid. The black panties are good, and the straining at the neck. The pressure of clothes snug to the body, clothes pulling with eroticism and death. And how fucked up is it that those two are so close together? Goddamn it, swimming is hard. I am so bad at drowning gracefully, slipping quietly into mermaid darkness. Instead, I flail on the surface, and maybe spit up a little. I have never opened my eyes under water. Now you know. I'm sorry. The chemical fish of my synapses flash too, too silver. The tail of whatever is next undulates. Perhaps this is all we get of mermaids now. It is hard to kiss.

Writer
Lisa Poje Angelos

IN FAVOR OF LOVE

She fancies herself the octopus
tentacles awash in color,
and he the ethereal jellyfish
billowing translucence of white,
the difference no greater than
that of man and woman,
certainly nothing to prevent a
simple sea creature's kiss, despite
potential complexities ahead.

Photographer
Jack Mader

BIKE 7585

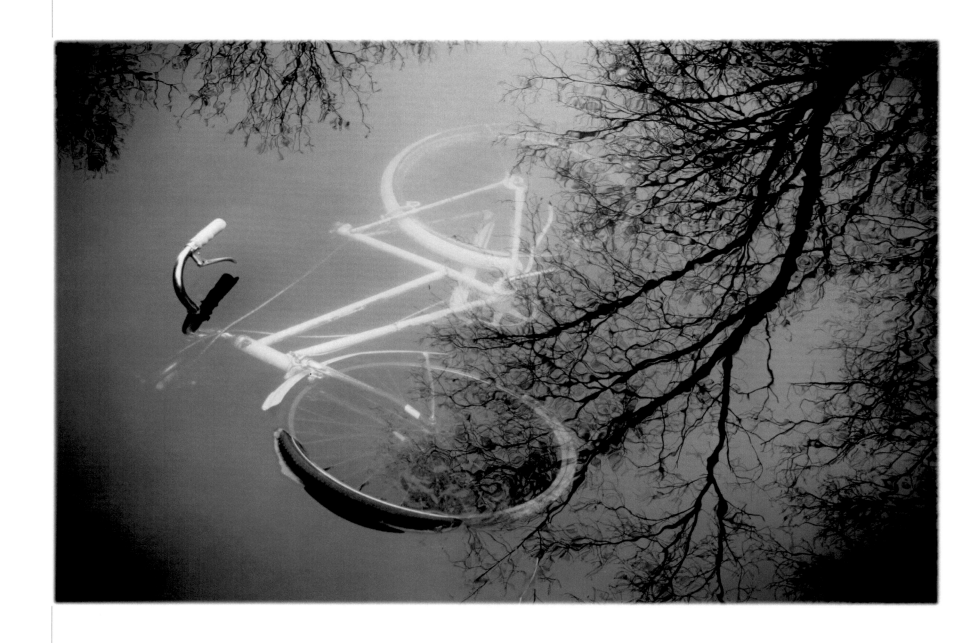

Writer
Sue Pace

WAS THERE INTENTION?

Were you pedaling out of that green pool
pushing from the bottom, breaking the surface,
blind as a tadpole, but anxious to take that first breath?
Is that how it was?

Or did it start in warm air
when you raced down a ragged hill
over brown dirt, gray rocks, green grass,
aiming for pale mist above a placid surface
gaining momentum faster and faster
leaping into a maiden flight
but gravity, that stern master of us all,
refused to release you?
Was that what happened?

Or were you chasing the sunset
following a broken
golden
path to the other side of the pond?

Tell me it wasn't a mistake,
this resting half-in and half-out of the water.
Say there was intention
in living between worlds.

Writer
Mieke Eerkens

DREDGE

The canals of Amsterdam horseshoe the city, cradling its people in a watery nest. We will stand on bridges in the summer dusk and watch the green and brick refracted in their endless mirrors, and we will stand on bridges in the steely winter watching snow alight softly on the canal's frozen stage. When the ice thaws in the spring, a barge lumbers through to dredge the bottom for debris. The barge's orange crane drops its claw into the murky depths to grope blindly into centuries of silt, and emerges with the skeletons of bicycles in its maw. Their rusted corpses rise through opacity and blossom onto the surface. They are piled onto the decks until they tower in an aluminum shrine to the rattling of wheels over cobblestones and the echoes of bells against the houses that witnessed it all. Twelve-thousand bicycles each year, excavated from this mass grave. When the barges become still under Rembrandt's dimming sky, the ghosts of the bicycles will begin to whisper about what they saw down there. They speak of the dead bodies — an average of three per year fished up amid their twisted spokes — like the drunk who toppled in; the adventurer who fell through the ice; and the aching soul who stopped her bicycle in the fog one night, under the ever-present specters of those who watched these canals from shaded attic windows before they were ratted out and dragged away. See her now, her bicycle white like bone beneath her seat. She looks out over the canal, contemplative for a moment. Then she rides and sails, air-bound before sinking fast, finding her way through the still waters to the city beneath the surface — a city swallowing decades of pain and welcoming her into its fold.

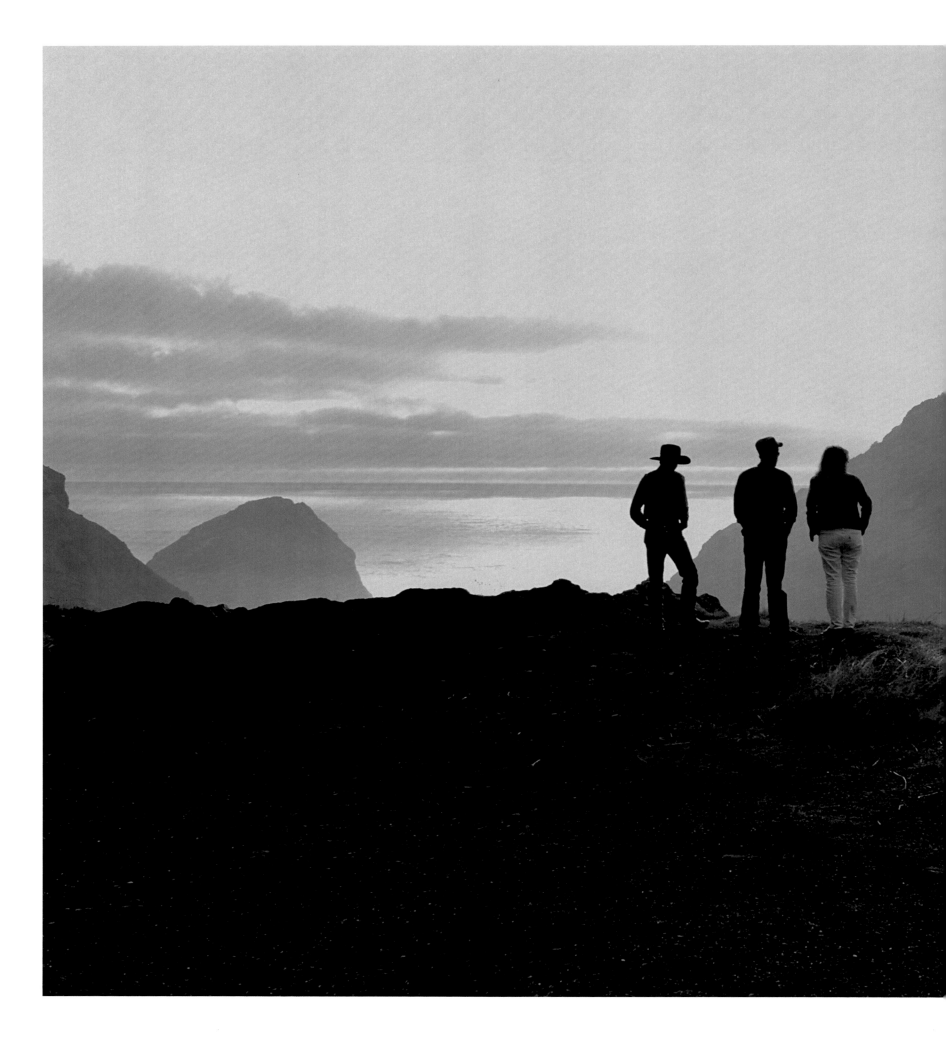

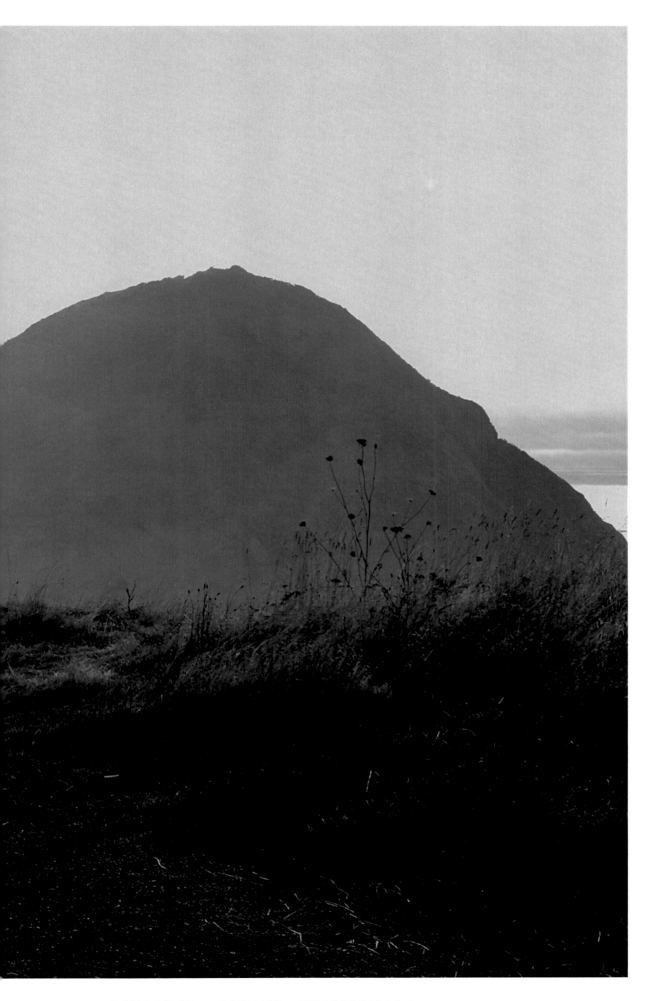

WATER'S EDGE | OPEN TO INTERPRETATION

Writer
Josiah Titus

FAIRLANE

She says it's the cold. He asks who considers Cincinnati cold. What she needs, she says, is a fresh start.

Her bus arrives and he's there, waiting in his car. He pops her door open from the inside. You've come to the right place, he says. He says she can stay however long.

They stop for gas and he asks if she can chip in, or if this is another free ride. She asks when has he ever given someone a free ride, then gives him a twenty. He pumps ten, goes in, comes back with two Cokes, a pack of cigarettes, and coins for change.

They arrive at the Ocean Vista Motel, which he says is temporary.

Both beds are unmade; his clothes cover the floor. He calls the desk and asks if the housekeepers have quit. She says she's hungry. He tells her there is a bar next door.

The waitress brings him a double-bourbon and soda, which he snatches from her hand. He orders two cheeseburgers, a plate of fries, and a Coke for her. She tells the waitress water is fine.

A cowboy sits at the bar. He watches them, laughing and saying things only the bartender can hear.

She says to never mind, to ignore him, but he turns to the cowboy and says something, then gets up and says something more. His keys are on the table. She grabs them and walks out.

Across the highway, at the bottom of a cliff, is the ocean. She drives straight for it — stopping at the very edge — then waits. She waits until she can see him in the mirror, running and shouting, his arms waving for her to stop. She watches until she can see his face, then lifts her foot from the brake and gets out.

Writer
M. P. Keen

AFTERCLAP

Do you suppose he's still above snakes?

Nah, he's gone. Buzzard bait.

Been waitin' so long for this. Too long.

Milestonemonger got his due.

Yeah.

You feel different? I don't feel different. Not like I was expecting anyway. I thought I would feel different. Feels like a bed of nails.

You talkin' may hay? Nah.

Me? I'm right as rain. All-fired happy. Ready to celebrate with some coffin varnish!

Do you think anyone'll find him — come looking?

Yep, ready to get me some rooster.

But do you think? I just don't feel...

Who's gonna look for a flat waddy like that?

Yeah. What a base burner. A blow out.

We did the clean thing. Stop puttin' a spoke in the wheel.

But if they do? If they do come looking, then...

So what if they do? Pull in your horns! From here on out: corral dust.

Yeah — corral dust.

Feels like a bad box to me. Something's not right.

Brisk up! You're talkin' burro milk.

Both of you: stop with the bobbery! It's gettin' to be fussed dark and I'm ready for some red eye! You bull nurses comin'?

Cowboy is right. We need to pull ourselves together.

And neither of you Nancys let on, you hear? You keep that dry.

Photographer
Jack Semura

THE LAND'S END

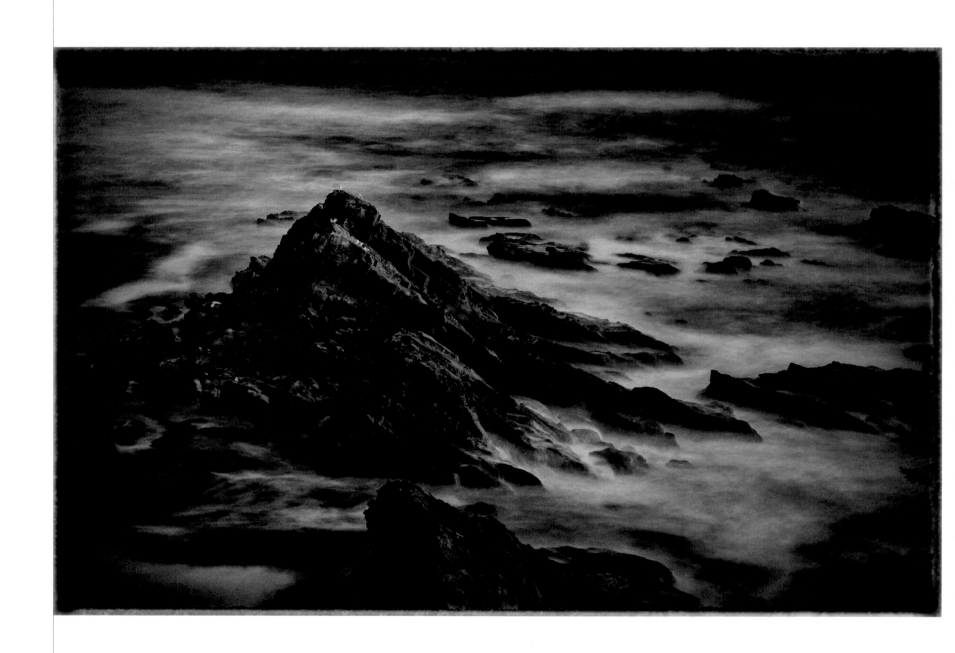

Writer
Laurelyn Whitt

CONFLUENCE NEAR PUGET SOUND

Four rivers flow
in tandem here:

the Hoko and the Sekiu, the Elwha
and the Clellam. The pull

of brine overcomes them,
 a longing to slip
 the lock of land, to merge with
 one another,
 dissolve into the sea.

I stand among them
 so still the gulls stretch
 their necks,
 cock a single eye at me

and forget the body
I am, how it hugs the earth;

 so still that words cannot
 find their way

and lull me to sleep
in the sweet silence
of oceans.

The gulls, unblinking, pin me
to the world, to the Strait of
Juan de Fuca

this strip
of sand.

Beyond, the huge, beating
heart of the Pacific breaks
and rises

 rushing toward me.

Writer
William Wenthe

THE LAND'S END

Among the many birds
God tells Noah to harbor
in the medieval play

are fulmars. Creatures
of northern oceans, they shun
the land, nest on sheer

sea cliff, earth's edge.
Abiding in wind,
slumbering on sea swell —

how might Noah even hope
to catch one?
A lesser question, perhaps;

a greater one is why
the anonymous clerk who crafted
this mystery play to teach

unlettered peasants and townsfolk
of England, would list
among redshank and rook

and familiar others
the far-faring, haar
and spindrift fulmar.

What vast arc
of love is this, that may be conveyed
in a human ark —

even as these fisted rocks,
upthrusts of earth's crust
giving perch to white seabirds,

are held, unblurred
amid savage surf, in the lens
of the artist's machine.

Photographer
Jeff Korte

MOORING

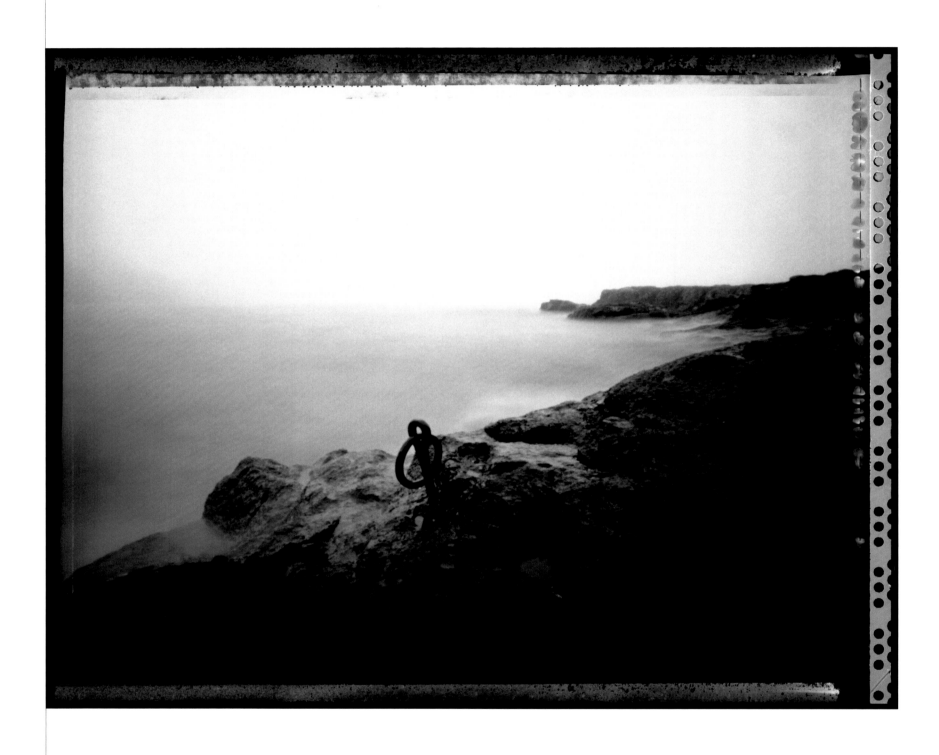

Writer
Alison Jean Ash

MOORING

My mother was a seal. A Selkie, she never knew it till she came to bask on the summer rocks and so loved the sun's brief heat that she slipped out of her sealskin as I might take off my shirt. She spread out her dappled pelt and lay on it, arranging and rearranging her surprising new limbs until she was comfortable, and then she fell asleep.

At dusk, my father rowed in with a good catch, but a better catch lay on the rock. Her pearly skin was flushed rose-gold by hours of sun behind gauzy cloud; her long hair drifted loose in the breeze. He stared, and then mooring his boat, he leapt ashore.

Waking, she saw him, and was captive. She could swim no further than the twin pools of his eyes. It was not a craving for love or sex that drew her, but the perilous lure of entanglement: her long new legs around his waist, his fingers in her hair. Without a backward glance, she stumbled on unaccustomed feet to his cottage, steadied by his arm. The next morning, her sealskin had vanished, gone with the tide.

Two children she bore him before they parted. The children moored her to the rock and she forgot her nature. Every day, she walked by the sea yearning, mourning, trying to remember.

When she was dying, I sat beside her and watched the life ebb from her ocean-colored eyes. Dull as dry pebbles they were now, pebbles that gleamed in water — such magical hues.

I saw a new tide flow in. Her torso thickened, reabsorbing her limbs' length. Sleek fur clothed her massive and powerful body.

Last of all, her face changed. She looked at me with eyes grown wet again, round and dark, and then she swam away.

Writer
Catherine Watson

THE MOORING RING

One glance, and the heart recoils, concluding that this is a picture of loneliness and loss. But look again. Look *beyond*. And don't be fooled by the lack of color: black-and-white always tells its own truth, and it's seldom as simple as what's on the surface.

Take away knee-jerk emotion, and all that's certain on this surface is rock and sea and sky — three alien elements anchored by that stark iron ring, the way a boat should be. The way a boat *must have been* — many boats, more likely, over many years.

There is no telling where those boats are now. And no way to know what else we cannot see.

Perhaps a small stone cottage, its windows glowing gold with evening lamplight, is hunkered down behind us, well back from the buffeting winds of this shore. Or maybe there's a tavern near, and wisps of laughter and home-spun music are drifting out, calling louder than the winds. There could even be a boat just out of sight. But is it outward bound or coming home?

That is travel's half-full glass. The things that don't show make the mooring ring a symbol of *home* as well as of *distance* — the *yin* and *yang* of travel's own nature.

For real travel, there always has to be a mooring ring — somewhere to tie up the bowline, catch one's breath, seek something new or rediscover something familiar. The ring means a place to come home to, as well as a place to loosen the bonds and go forth. It is always being left behind or sailed toward. Travel demands that too — the coming-back, the return to tell the tale to others.

Without a mooring ring, the boat's adrift. Without a homeport, travel isn't travel — it's only emigration. The counterpoint is essential: seas aren't always smooth, coasts don't always welcome. But stern coasts make sweet harbors, because they are so rare.

Photographer
Kat Moser

NAIAD RISING

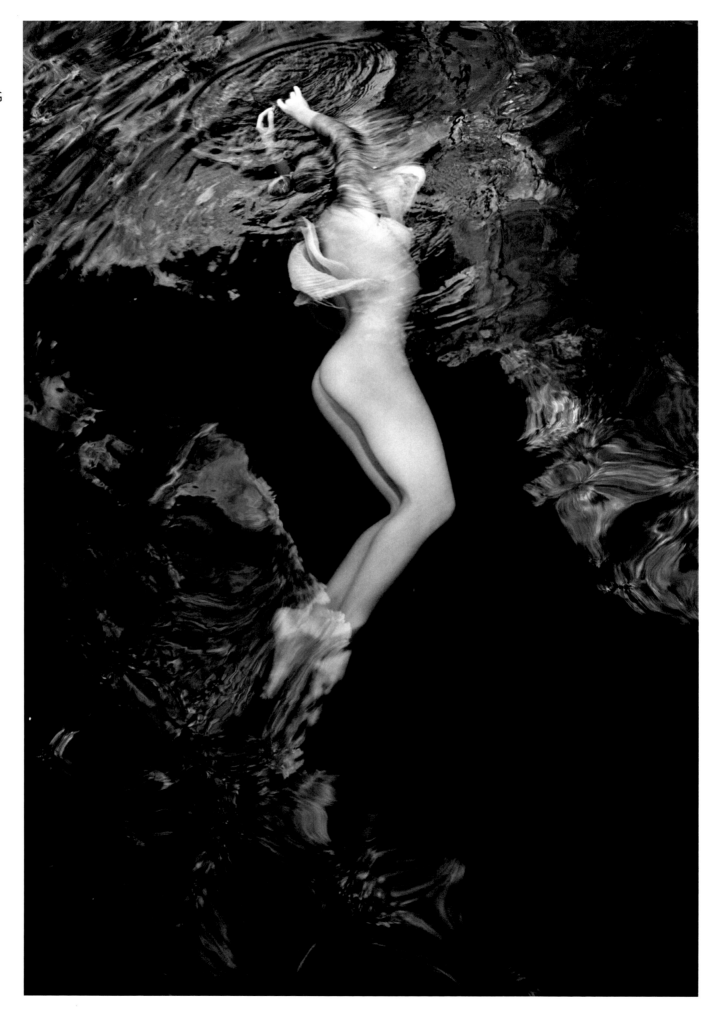

Writer
Beebe Barksdale-Bruner

SPRING

Spring gathers her fabrics precisely
as a mourning dove layers fluff
over cradled twigs.

She drags tides in the hem of her gown
and ruffles haze around the moon,
promising rain soon.

Pillowed clouds hover over land
and shade broad seas aubergine.

The rains come. She sleeps
in salt-water mysteries
of her beginning.

Writer
Pablo Medina

DEAD ANGEL

Early in the soup of things
the angel dropped to the waves
and sank to where her wings
flapped against the mud of hope.
Hair splayed over her face,
fish nibbled her toes
and pearls floated up
from her ears like promises.
I think she was dead
or sleeping an eternal sleep.
They pulled her up by her nose.
Next to the body the Chinese
fishermen stood and smoked
and the Spanish managers
barked their orders to throw
her back. *Basura.*
No splash, just a slow descent
into the realm of effluence.

Photographer
Mary Ann Reilly

SURFACED

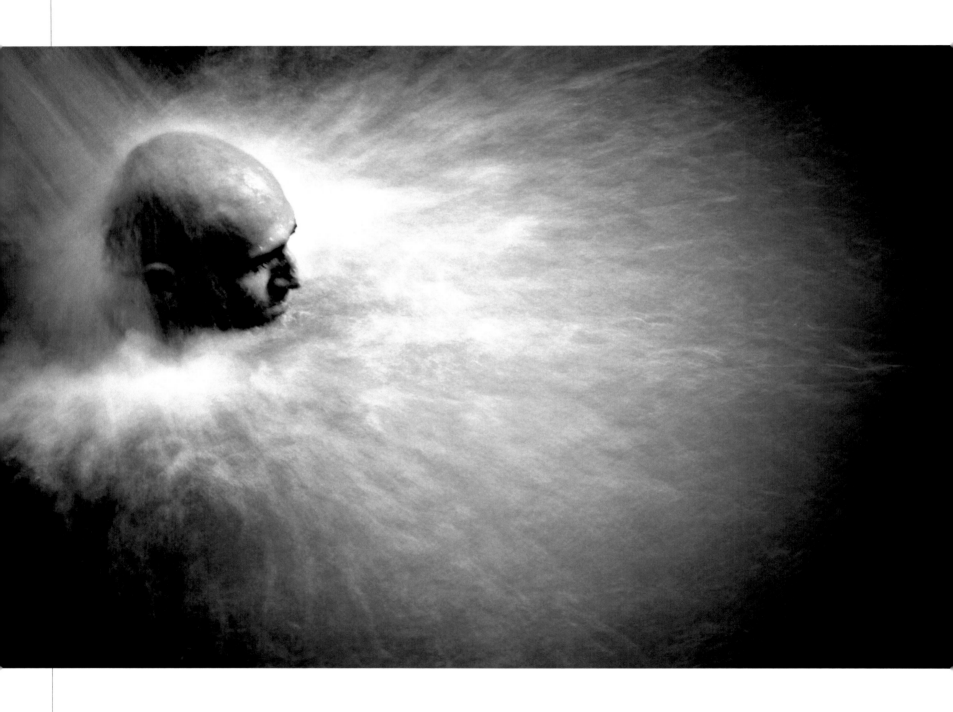

Writer
Jim Moore

UNTITLED

He's in it up to his neck now. As if that's not enough, it's raining down on him from above. This is not about happiness or sadness: he's concentrating so hard, you can see just how difficult it is being a human, to tread water, to keep your balance, to do what the photographer wants. Yes, he's showing us how strange it is to be us. His black lashes, his cheek giving off light so we can see our way in the dark, a light that says: whatever made us think we were put here to reach the other shore?

Writer
Julia Morris Paul

SOUND CARRIER

When the lake is calm like this,
I don't think about conversations
with the dead or nearly dead,
voices that dissipate like skywriting
on a windy day. I don't think of cemeteries
pockmarked with loss, clothes
stiffening on the line — not until the sky
falls into the water and the clouds
float like ghosts, not until the turtle
swims up to the dock, shell like
an army helmet, eyes like my brother's.

The tossed stone stirs the images:
the doll he brought me when I was sick,
the uniform that gave him hives, the war
that darkened his beardless face,
the white crescent smile like a new moon
in the photographs.

To win the lottery was to lose.
Numbers were assigned like horoscopes
to birthdates. Drum roll, please,
for lucky number eight! We stopped
praying then. Father bought a tape player,
recorded dinner conversations
that included him as if he were still
at the table. Weeks later, my brother
would listen to our laughter, complaints
about homework, what was on television.

Stop. Rewind. Play. I picture him
in sulfurous rain, engulfed in clouds
of fog, wet as washcloths. Vietnam.
Stop. Rewind. Play. Crank up the volume.
Our voices resound like front-line guns.
His head's full of words. Words swell
on his tongue like mosquito bites. Speak
into the mike, brother. The lake is still.
Water is a sound carrier. Lip reader it is not.

Photographer
Ron Horbinski

THREADED JEWELS

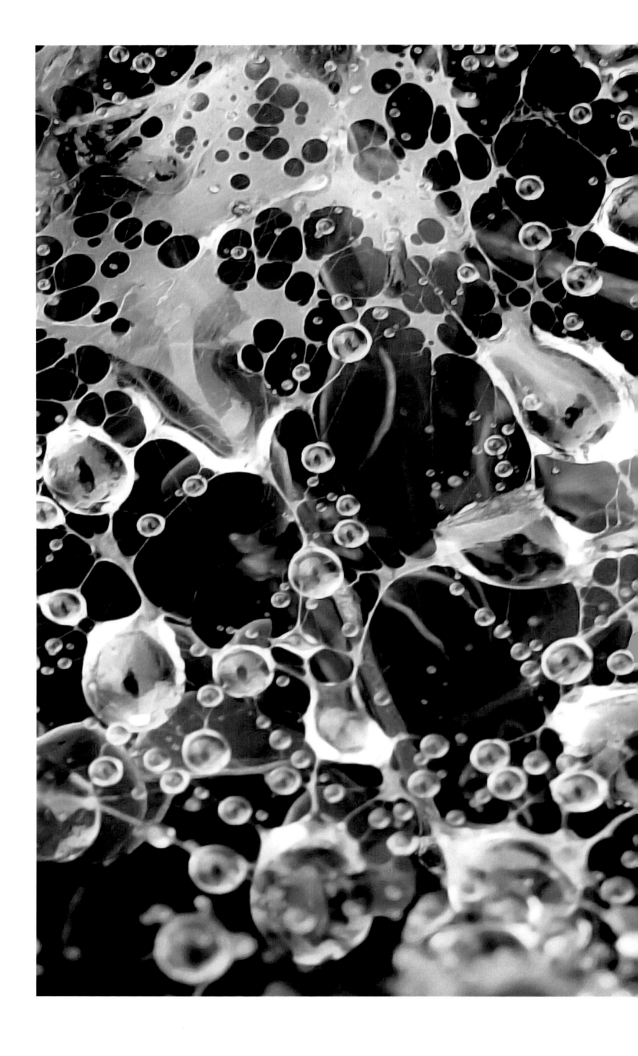

Writer
Maureen E. Doallas

ILLUSTRATING CELL DIVISION

Start with a length of thread.
Colored or not. Any length.

You decide.

Make of one end a circle.
Pull the thread through the eye.

Tighten it.

Let that become the first knot
below the surface, the bump

you discover that will begin slowing
you down, tangle you up in time, trick

you into watchful waiting, leave you
wondering when and how many more.

Now make another knot,

and then another, too,
and do this until the thread

is all bumps, big or small, the spaces
in between closing, closer, no longer

giving room enough for a run
of your fingers to trace the first

knot in relation to the whole.
This is the mass you don't ignore.

So:

Try to cut it in two or apart.
You'll notice how the thread, splayed,

frays, breaking some fragile connections,
thinning out what you cannot see.

No matter how careful you are,
once you begin the process of cutting

into and away, you lose sight
of beginning and end. You treat it all

as one and the same.
But consider the options.

When you're too late
you just leave everything,

alone.

Writer
Patti Frazee

UNTITILED

She steps closer to the edge of the river and squishes her bare foot into the sand, watching the wet, soft crystals ooze between her toes. She slowly takes a step closer to the water, then another and another, the river washing away each footprint she leaves behind.

The water begins to rise around her feet and ankles. Bubbles float up from the bottom as she steps into the middle of the shallow river. She eases herself onto a sandbar. Water soaks into her cutoffs.

Bubbles swirl around her as she immerses her hand below the surface, up to her wrist. She watches her hand move, suspended between the sand and the surface, gently pulsing with the rhythm of the river.

She wishes the water was glass, sharp and precise, as it moves about her wrist. She imagines the clear water turning crimson as she slips away and falls into the river, her long hair floating around her head as the sun warms her face. The river would invade her ears and her faint heartbeat would sound with the gentle pulse of the water to create a nothingness she could fall into.

Now, thunder rumbles in the distance. She looks out across the shallow river and wonders how she will ever escape.

Photographer
Moria Lahis

MOTHER AND CHILD, 2009

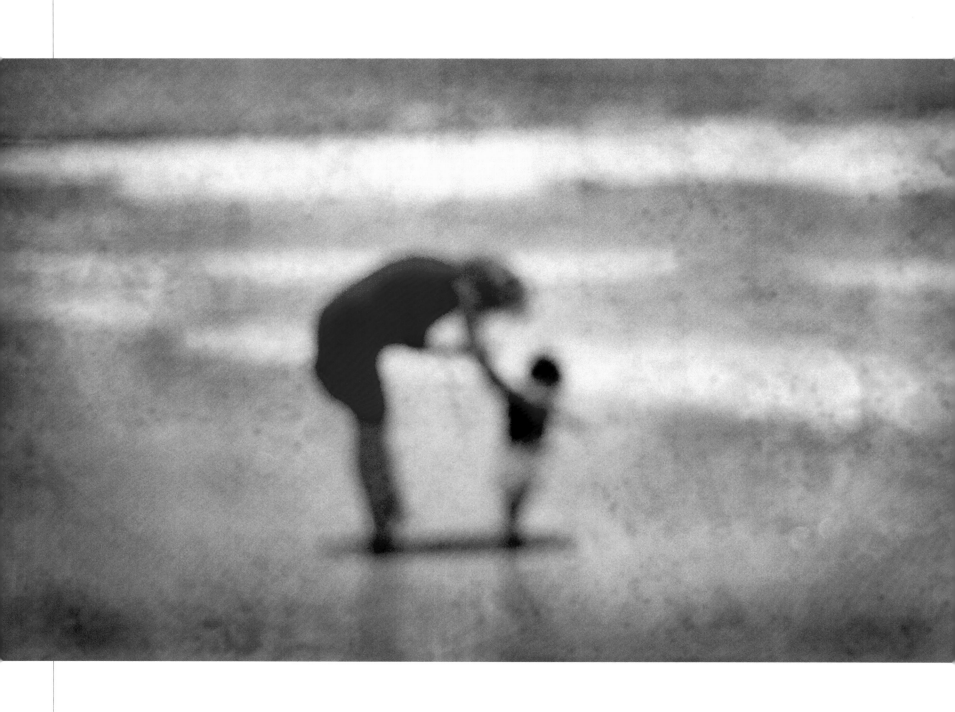

Writer
Lawrence Aronovitch

ELEGY

The car is loaded up and ready to go. Sheila comes out of the house sucking on her cigarette. "For God's sake," she says. "Let's get out of here."

I was born in that house the day that Kennedy died; Mother, the day that Roosevelt died. And her mother, whose face I cannot conjure, died in it the day that Truman dropped the bomb on Hiroshima. We measure out our lives in presidents.

Today the house is empty and I listen to the water and let its salt intoxicate me. I drift back to a time when I was holding Mother's hand, learning to negotiate the surf as it lapped up on the beach. The cape was my happy playground then, filled with wonders to discover — seashells, dune grass, the mysterious creatures in the water, and always, the mournful birds hovering, held aloft by the winds.

But that day the sea was a sad greenish-gray like the faded shingle siding of the house. Mother wore her favorite beach dress, the bright scarlet one, and whispered in my ear to run back and get the salt water taffy she'd bought at Tuck's Candy the day before.

I ran exuberantly through the house, into the kitchen, and found the hoard next to her Sunbeam. Selecting a licorice one as my fee, I took the bag and hurried back to the beach. But amidst the sand and green and gray, Mother had vanished.

Later, I remember sitting at the kitchen table with my bag of taffy when they came to tell us they'd recovered the body at low tide, her dress torn and stained with sand, no longer red.

Sheila gets in the car, looks at me, and drives us away.

Writer
James Harms

ORPHEUS BEACH

He wishes he were worn out. Not broken
exactly, but crumbled, singed at the edges.
As he's said before, he's sick of gravity.
And the acoustic interpretation is a way
of securing a softer truth, though he misses
his old friend (what was his name?),
misses the counterpoint of lead guitar,
the always flat inflection at the edge of
what? Where is he? This stretch of sand
looks like a Roman road gone to shell.
And a red flag has torn loose of
the lifeguard tower and wrapped his mother
like a terry-cloth dress, dual purpose couture.
Then again, all memory is pixilated, just
wind hiss and wave blur, sand pitting
the lens until his father gives up, walks
east forever, drops the camera on the beach.
Sleep, whispers the sea. It always does.
And when he awakens he's the only one
left alive, immortal as the song in a seashell.
His song. One more time, she says,
this new face in the crook of his arm.
She kisses. He sings. And then it starts
all over again.

Photographer
Ning Fan

YESTERDAY

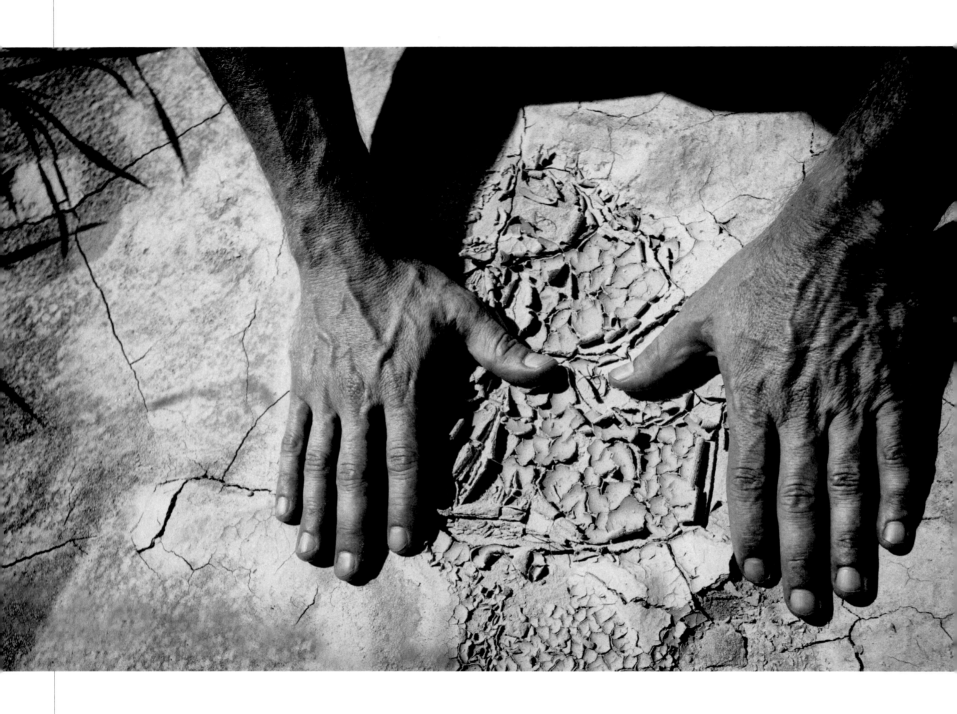

Writer
Michal Milstein

PRIMAVERA

The Maya told me that Day set out from the east and started walking. Time was not, they said — Fog was not, and Water went. No otters or wrens or others. On his journey, Day created Sky and Earth, but waited before it built the stairway to the clouds, holding back Water in the void like shameful tears. He stuck out his ray to write in the sand: *The primavera sleeps thirsty and trapped above a new life unlived.*

The sand fell away at his nail, the poem seething and distorting into an arid dent. "If I invite Water," thought Day, "I will be absorbed and tossed away in the cycles of the sea. The land at the bottom of the deepest lakes will forget me. But without water, I cannot carve a word."

As he sat, the land began to dry and dry, until it cracked into fault lines and flaked like scales husked from a breathless fish.

"If I invite Water, I will be able to see my terrible reflection." He plunged his rays into the sand and watched it sublimate to a filthy haze.

"If I build the stairway, things will slip." Flecks of baked earth clung to him like burls.

"If Water comes down, I must stay up." He pulled up his rays, which had sunk a lifetime into the sand, and pulled them across the surface of the land — but this time, he left holes.

His fingerprints tugged at the earth and created mounds. His mind reeled as he watched the earth dampen around the lifetime-deep wounds.

He felt a bubble rise in his chest.

Water had never left.

Writer
Quince Mountain

THE WHISTLEBLOWER

I stayed for a while in a large lodge with a man named Rick, who was called the whistleblower of the year. He told people that the EPA was lying, the president was lying, and the land was not lying, but getting warmer.

Those of us at the lodge would ask this Rick how he was doing and he would always answer according to his levels. "My levels are good," he would say, by which he meant that careful arrangement of caffeine and food and sleep and medication was keeping him within a range of healthy functioning. When any of us passed through the living room, there was Rick, sitting in his chair in the corner, reading the newspaper and eating a crumbly cookie. He always said hello when you wanted him to and just sat reading his paper when you didn't.

Several women at the lodge said that Rick could've been their dad. Which meant, I think, that he was sixty-something and that he was kindly and harmless and had crumbs on his shirt. This also meant that Rick, as I remember, had worked at some office, doing some officey work for the government, and that when he first saw how someone was erasing information, adding other information, he thought the president's men would surely want to know this — would surely make it right. Only much later did he begin to make some copies, make some phone calls, remove his coffee mug from the break room.

There was also another man at the lodge. That man studied the warming of the land, too, and if you asked him how he was doing, he might have said "well" or "shitty," but he did not say, "My levels are good." That man, when asked what we should do about the warming of the land said, "Teach your children to fight with knives."

Photographer
Peter Kurdulija

I OFTEN FIND YOU AT EXTRAORDINARY PLACES

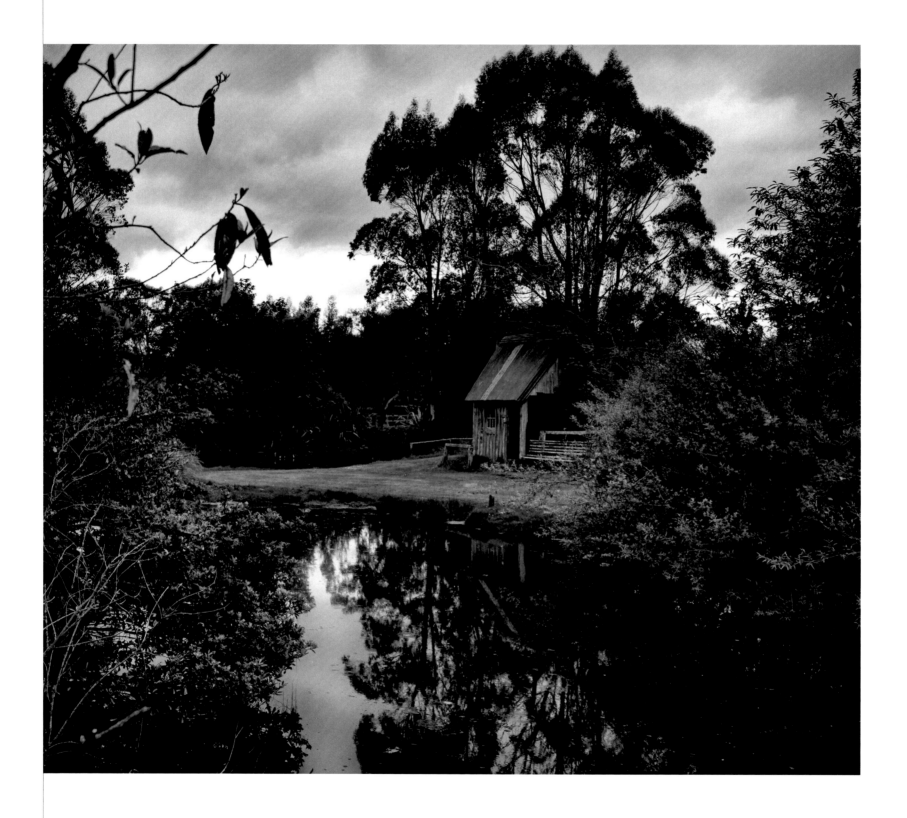

Writer
Karen Cohen

THE POND

You didn't go in that pond if you lived there. You knew better. Visitors might want to jump in if it was hot enough, but we'd just smile and watch them, no verbal warnings. They might feel something nibble at their legs as they swam around. Laughing, they'd kick a little harder at whatever was below. The water was so dark and often muddy, you couldn't see into it. They never knew — they'd just giggle nervously and thrash around. Mama would bop me on the head when I snickered at them. You just didn't go in that pond if you lived there.

Writer
David Lawrence Grant

PUNK-ASS WALDEN

I stopped for Ruby because it was raining, and she looked like a cat somebody'd chucked in the river. She appreciated the warm food and dry clothes, made happy talk about how she'd stay on a while, kick her meth habit and then maybe move to Virginia and go to community college for nursing. But in the cold light of day after day, we both saw that life without meth wasn't working for her. And how everything I loved about my place, she hated. Hated the moss and lichens between the beams of my walls outside; hated the closeness of my little shed inside — how what I called "cozy" made her stir crazy. Out of boredom, she listened to all my music and read all my books, but she hated them, too. Caught her reading my journal yesterday.

"Jesus Christ!" she said. "You're crazy! I'm no goddamn psychiatrist, but you got major effin' damage. And guess what? That pond of yours is nothing but a shitty little stink-hole of a swamp. And you're no goddamn Henry David Thu-rew neither! Your little fake-ass, punk-ass Walden is bullshit!"

It's not about her being white and me black, or her not yet 25 and me 50, or her being junkie and me sober. It's that I spend my days here trying to feel something again, and she spends her days trying not to feel anything at all. So, this morning, I dropped her at the spot where I found her.

I love how new the world looks after a storm. And now, after Hurricane Ruby, I find myself noticing now how beautiful the fading light of autumn really is. Winter's coming — a good time to think and dream. I'll keep a candle lit for all the Rubys of this world and wait for spring.

Photographer
Silke Hase

PEGGY'S COVE

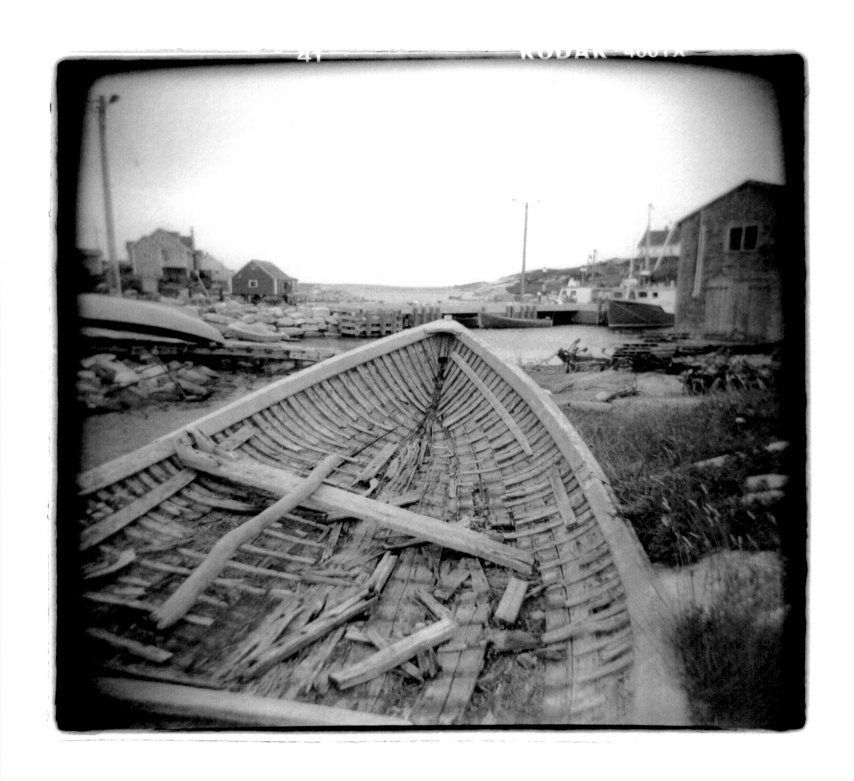

Writer

Lynn Tait

LEFT IN HER WAKE

When I ask to sign on, she laughs, "First mate? Bilge rat?" Either, or — I'd say a fair bargain, though it makes no difference. I'll be jettisoned first sight of a storm. She'd rather sail alone, too afraid I'll lead her aground in dangerous waters or betray her. She believes I work for a secret naval fleet, wanting to confiscate her heart, her love for still waters, but I've no stomach for high-seas intrigue; there's no mutiny on my menu. But I am what she needs — a breakwater to calm the seas, cut the waves — a special pier, with room only for her iron-hulled ketch. But her mind's made up — a gyroscope, axis fixed yet free to turn everything into a battle, laconic war with silences more destructive than if she'd just fired one long-winded salvo or launched a sudden spasm of warfare using everything she's got: *damn the torpedoes, full speed ahead*. She won't sign me on — compass always pointing in the same direction — embarks on a voyage avoiding rough terrain and rocky harbor, never sailing against the current or dropping anchor until the coast is clear.

Writer

Susan Thurston

A BOAT CALLED LEAVING

This craft once was whole. We had not been crushed, reduced to shims, shards, fibrous echoes, salted-dream remains. Back then, the voyage out to you meant everything. Now you list to one side. Blindness encroaches. You cannot remove enough splinters from your eyes to regain your sight. How will you navigate the hollow bell? All those who knew you in this village called childhood are gone.

Here. You lift the bow. I will carry the stern. We will bring this fragile body — skin rough, longing for the launch, salt laden — to the water's edge. In this boat dry as leaving, some of you, some of me, will be carried away, down the channel, past the white cottage on the rise, just beyond that dune where once, as the village slept, we stretched next to each other and whispered stars.

We taste the sea air, oily with rack and ruin and sweetness — terrible, terrible sweetness. It lines our lungs. The sea is seamless and unseemly in its calm. When we dip your oar, my broken plank, into the water, aching trails of our empty our arms linger. With each breath, we brace for the inevitable, still invisible, season of wailing. Take your hands and caress my ribs, press against me and listen. It will come. When that first wave approaches, there will not be room for fear and we will not abandon this craft. We will lift anchor and ride into it. We will remain a mystery to the water, and the wind will muffle the prophecy from our mouths. We will find ourselves weightless and without a face. We will demand of the water what it must do. It will bear us up, shadows.

Photographer
Tanja Mamas

SINK OR SWIM

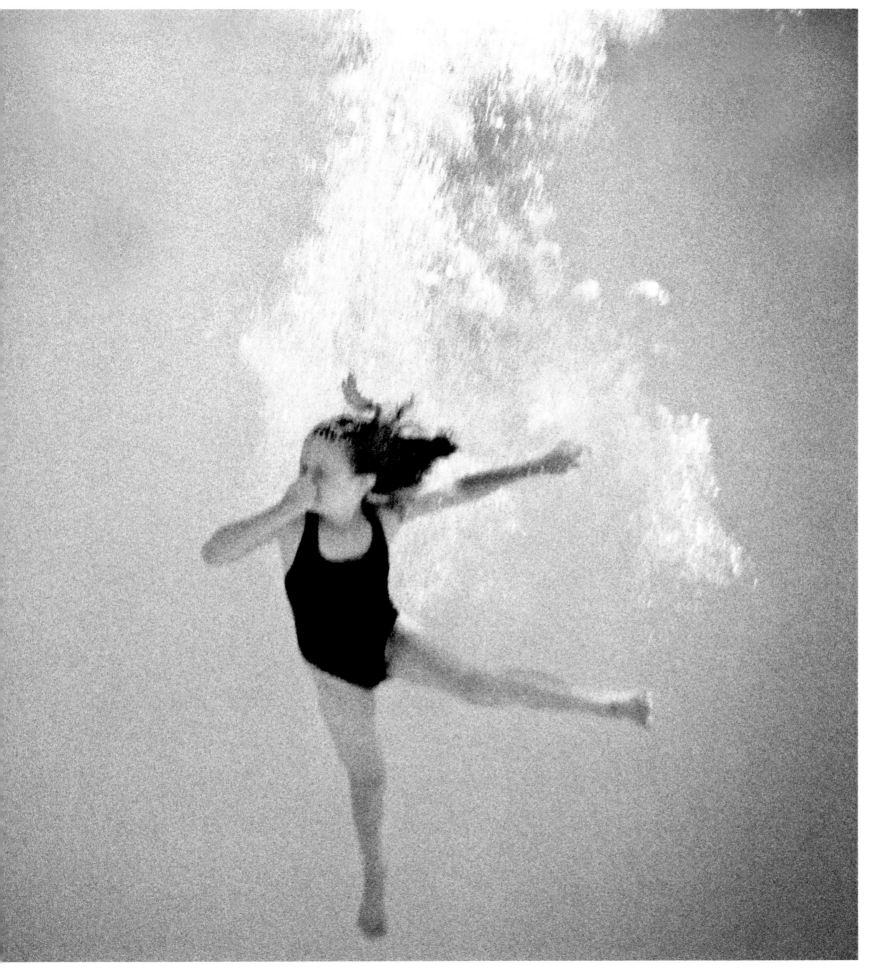

Writer
Susana S. Martins

DOWN DEEP

"I like to dance," Ella announced. She was dripping from the pool. "You should see me dancing down there."

She wanted me to go in with her, but I had my book and my wine and I was not interested.

"Stop that," I said.

She was wobbling one of her front teeth back and forth. I'd told her a dozen times it would come out on its own.

"It's moving," she said.

"Good."

A minute later I heard a splash. She'd gone in again, down deep. A great swimmer, my niece. Fearless.

She was back. I pointed to her towel. She wrapped herself in it and sat on the edge of my lounge chair, forcing me to move my legs.

"When are you going to have a baby?" Ella said.

"Why?"

"I want one."

"So have your own."

"I want you to have one."

"Why would I?" I said, sipping my wine. "It'd probably turn out just like you."

She giggled. "Have a boy," she suggested.

"Good idea. Will do."

"When?"

"Later."

"Tomorrow?"

"You bet."

"Can I name him?"

"Only if you shut up while I finish this chapter."

She giggled again, then rummaged through the cooler for a snack. I stared at one page of my book for a long time, watching the print grow blurry, glad for the sunglasses that hid my rapid blinking.

"Look!" Ella cried. "I have something for you."

"Don't tell me. A diamond? A pearl?"

"Noooo," she said. "Close your eyes and hold out your hand."

So I did, some requests being easy to grant.

"Now open!"

I looked. There in the center of my palm lay a tiny white tooth. Ella grinned, showing the gap in her smile, and I grinned back through my tears, and slowly closed my hand.

Writer
Karen Cohen

BUBBLES

When I was young, we had an above-ground swimming pool
in our backyard. Every summer, I lived in that pool, ignoring my
wrinkled fingers and toes. The water was my playmate and
I hardly cared if I rode bikes with my friends, I just wanted to
swim in the pool. Every day.

Jumping off the wooden platform my dad had built, I would
sink quickly to the bottom of the pool. I'd hold my nose and feel
the bubbles pass my face and ears. I'd blow out for as long as
I could to create that tickling stream. Then I'd push down on
the pool floor with all my might and spring out of the water,
gasping for air.

Dramatic, yes. I often imagined I was a Weeki Wachee Mermaid.
They were featured on a TV commercial for a water attraction
in Florida and I was mesmerized by their underwater antics
and beauty. They could hold their breath for eternity (only a
bubble or two would escape their smiling ruby lips) and their
eye makeup was always intact and never smudged when they
waved in slow motion to the onlookers who stood outside
the see-through tank. Oh, they were beautiful! And that's what
I pretended to be: an underwater mermaid.

For our inaugural edition, we've asked our judges to interpret each other's work.

Photographer
Douglas Beasley

LAVA MAN,
KILAVEA, HAWAII

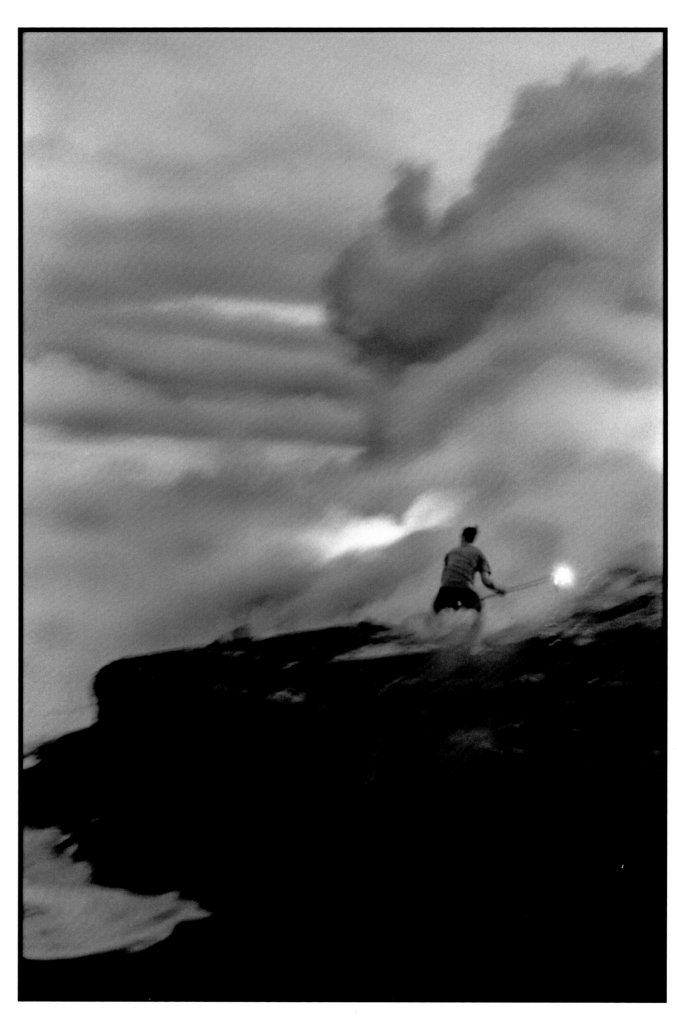

Writer
Anastasia Faunce

ON EDGE

When you put the glass of water before him and say that's it, no more, it's over, he says it's not. He's all yes to your no, all faith to your reason, preferring to hope rather than believe what science has proven, again and again, to be true. The way he sees it, everything will work out, be fine, but you know that's not true and try to convince him using as few words as possible. You tell him it's certainty you need, that it's not about praying for a sea change or shifting fault lines. What we need, you say, is discipline, a plan. But he's all silver lining to your dark cloud, all Aquarian air to your Arien fire, and trusts that planetary alignments and oceanic tides, those miraculous tricks of time, are assurance enough. But you, you are frantic, so you invoke history, the very first century, the Roman freaking Empire. Say: What about Vesuvius? Herculaneum? The horrors of pumice and ash suffocating the people of Pompeii? You throw your hands up in a dramatic sweep that causes a wave to crash over the rim of the glass. He looks at you — the wasted water — in a way that suggests you are responsible for draining the earth's last fresh-water body, in a way that suggests irreconcilable differences, a failure to meet eye-to-eye, but more, in a way that suggests that he is beginning to comprehend the endings of couples who were once as doomed as the two of you. When he leaves, crosses the threshold, it feels as if there is a range of mountains between you, a mock border that spans the equator of the door's still-swinging frame. You imagine the terror the Italians must have felt as they ran toward the relief of the nearest shore — the ashen air blurring the strict coastline, that decisive demarcation between life and death — knowing full well that even water could not save them and that they would be preserved eternally in their final states of believing. You run your finger along the endless rim of the glass, look inside at whatever clarity remains, and think: who's to say really, half-empty, half-full? We could go on like this forever.

PHOTOGRAPHERS & WRITERS

Wendy Amundson
Edina, Minnesota
wramundson@aol.com

Lisa Poje Angelos
Two Harbors, Minnesota
lisa.poje.angelos@gmail.com

Carolyn Cray Arnold
Minneapolis, Minnesota

Lawrence Aronovitch
Ottawa, Ontario
laronovitch@gmail.com
www.aronovitch.ca

Alison Jean Ash
Bremerton, Washington
alisonjeanash@gmail.com
http://pugetsoundblogs.com/wordspider

Elizabeth Brooks Barnwell
Minneapolis, Minnesota
eb.barnwell@gmail.com
www.elizabethbarnwell.com
612-977-0444

Douglas Beasley
St. Paul, Minnesota
info@douglasbeasley.com
www.douglasbeasley.com
www.vqphoto.com

Ana Mae Bellisio
Brooklyn, New York

Kris Bigalk
Minnetonka, Minnesota
kris.bigalk@normandale.edu
http://krisbigalk.wordpress.com

Craig Blacklock
Moose Lake, Minnesota
craig@blacklockgallery.com
www.blacklockgallery.com
218-485-0478

Barrie Jean Borich
Minneapolis, Minnesota
www.barriejeanborich.net

Blair Braverman
Iowa City, Iowa
blair-braverman@uiowa.edu

Nan Brown
Quincy, California
nan-brown@sbcglobal.net
www.nanbrownphotographs.com
530-283-3631

Beebe Barksdale-Bruner
Charlotte, North Carolina
beebe.barksdale.bruner@gmail.com
www.beebe-barksdalebruner.artistwebsites.com

Gia Canali
Burbank, California
hello@giacanali.com
www.giacanali..com
415-839-6632

Karen Cohen
Waxhaw, North Carolina

Daniel Colavito
Philadelphia, Pennsylvania
info@danielcolavito.com
www.danielcolavito.com

Jaimee Wriston Colbert
Endicott, New York
jcolbert@binghamton.edu
www.jaimeewristoncolbert.com

Johanna Commins
Auckland, New Zealand
www.deadpoetrybird.blogspot.com

Rosemary Ann Davis
Minneapolis, Minnesota
rosemarydavis3@mac.com
www.mnartists.org
651-645-7179

Maureen E. Doallas
Arlington, Virginia
http://writingwithoutpaper.blogspot.com

Mieke Eerkens
Iowa City, Iowa
www.miekeeerkens.com

Ning Fan
Fairfax, Virginia
ningfanphoto@gmail.com
www.ningfanphoto.com

Anastasia Faunce
Minneapolis, Minnesota
www.open2interpretation.com

Patricia Weaver Francisco
Minneapolis, Minnesota
pwf@bitstream.net

Patti Frazee
St. Louis Park, Minnesota
pfrazee@pattifrazee.com
www.pattifrazee.com

Douglas Frierott
Portland, Oregon
info@douglasfrierott.com
www.douglasfrierott.com
760-522-5424

Jennifer Gardner
Brooklyn, New York
jrgardner310@gmail.com

Rigoberto González
Forest Hills, New York
www.rigobertogonzalez.com

Cynthia A. Graham
Florissant, Missouri
graham@cynthiaagraham.com
www.cynthiaagraham.com

David Lawrence Grant
Minneapolis, Minnesota
davidlawrencegrant.writer@gmail.com
http://transatlanticlostandfound.blogspot.com

Susan kae Grant
Dallas, Texas
susan@susankaegrant.com
www.susankaegrant.com

James Harms
Morgantown, West Virginia

Lisa Hartmann
Longmont, Colorado
1000wurds@gmail.com

Silke Hase
Malden, Massachusetts
silke@creativemomentz.com

Geoff Herbach
North Mankato, Minnesota
www.geoffherbach.com

Jim Heynen
St. Paul, Minnesota
www.jimheynen.com

Ron Horbinski
Mequon, Wisconsin
horbinsr@gmail.com
www.printsbyron.com

Kirsten Hoving
Middlebury, Vermont
www.kirstenhovingphotographs.com

Anna Hurtig
Bromma, Sweden
contact@annahurtig.com
www.annahurtig.com

Susan Jacobs
Brooklyn, New York
susanjacobs11@gmail.com

Mark Jaremko
San Mateo, California
mark@markjaremko.com
www.markjaremko.com

Joel Kaj Jensen
Minneapolis, Minnesota

Alec Johnson
St. Paul, Minnesota
alec@acjohnsonphoto.com
www.acjphotoblog.com

Yoichi Kawamura
Claremont, California
yoichikawamura@yoichikawamura.com
www.yoichikawamura.com
310-528-5374

M. P. Keen
Santa Fe, New Mexico

Jacqueline Kolosov
Lubbock, Texas
poppiesbloom@usa.net
www.jacquelinekolosov.com

Jeff Korte
Minneapolis, Minnesota
jeffbkorte@gmail.com
www.jeffkorte.com

Peter Kurdulija
Lower Hutt, New Zealand
peter.k.new.zealand@gmail.com
www.fluidr.com/photos/peter_from
_wellington

Moria Lahis
Tel Aviv, Israel
moriyula@gmail.com
www.morialahis.com

Colleen Leonard
Montreal, Quebec
www.colleenleonardphotography.com

Milissa Link
Minneapolis, Minnesota
milissa@tolifeyoga.com
www.tolifeyoga.com

Cynthia Truitt Lynch
St. Paul, Minnesota
belmondostudio@msn.com

Jack Mader
Minneapolis, Minnesota
jack.mader@minneapolis.edu
www.jackmader.com
612-636-6791

JoAnne Makela
St. Paul, Minnesota
jaemakela@gmail.com

Tanja Mamas
Clyde, North Carolina
tanjamamas@me.com

Susana S. Martins
Chicago, Illinois
smartins11@mac.com

Justin Maxwell
St. Paul, Minnesota

Paul Mattes
Minneapolis, Minnesota
paul.mattes@usa.net
612-325-8813

Pablo Medina
Boston, Massachusetts

Michal Milstein
Studio City, California
michal-milstein@uiowa.edu
323-633-1517

Jim Moore
St. Paul, Minnesota

Kyoko Mori
Washington, DC

Kat Moser
Omaha, Nebraska
kat@katmoser.com
www.katmoser.com

Quince Mountain
Mountain, Wisconsin
www.killingthebuddha.com

Seamus Mullen
Avalon, Australia
stmullen@tpg.com.au
(61) 413 494 555

Gail Murton
Silver Bay, Minnesota
gmurton@me.com
www.gailmurton.com

Sue Pace
Everett, Washingnton
susaspace@aol.com

Abigail Stokes Palsma
Waconia, Minnesota
abbipalsma@gmail.com
www.facebook.com/abigailstokespalsma

Julia Morris Paul
Manchester, Connecticut
julia.paul@cox.net

Kristen Radtke
Iowa City, Iowa

Mary Ann Reilly
Ringwood, New Jersey
maryann.reilly58@gmail.com
http://maryannreilly.blogspot.com

Steve Saint-Aubin
Swansea, Massachusetts
rancho63@verizon.net

Sarah Rust Sampedro
Minneapolis, Minnesota
sarah@sarahsampedro.com
www.sarahsampedro.com

Jack Semura
Beaverton, Oregon
semuraj@pdx.edu

Elizabeth Siegfried
Toronto, Ontario
elizsieg@elizabethsiegfried.com
www.elizabethsiegfried.com
416-538-9585

Julia Klatt Singer
Minneapolis, Minnesota
julia@writeworks.net
www.juliaklattsinger.com

Agnieszka Sosnowska
Egilsstaðir, Iceland
www.sosphotographs.com

Matthew Specktor
Los Angeles, California

Joyce Sutphen
Chaska, Minnesota
www.joycesutphen.com

Charles Taliaferro
Northfield, Minnesota
www.stolaf.edu/depts/philosophy
/philfaculty/taliaferro.html

Lynn Tait
Sarnia, Ontario
lyta@sympatico.ca

Susan Thurston
St. Paul, Minnesota
hamer016@umn.edu
www.susanthurstonwrites.com

Josiah Titus
Minneapolis, Minnesota
josiahtitus@gmail.com

Marc Ullom
Niles, Michigan
mullom@mac.com
www.marcullom.com

Natalie Vestin
St. Paul, Minnesota
natalie.vestin@gmail.com

Catherine Watson
Minneapolis, Minnesota
www.catherinewatsontravel.com

William Wenthe
Lubbock, Texas
www.faculty.english.ttu.edu/wenthe/

Laurelyn Whitt
Minnedosa, Manitoba
laurelyn.whitt@gmail.com
204-867-5656

Joshua Wilkes
Boca Raton, Florida
jcwilkes@hotmail.com

Kevin Winge
Minneapolis, Minnesota
kevin.winge@gmail.com

ACKNOWLEDGEMENTS

This book would not have been possible without the generous support of the following:

Sue Amundson

Wendy Amundson

Connie Anderson

Dean Arnold

Jon & Linnea Asp

Judith Barat

Beebe Barksdale-Bruner

Patricia Barta

Joe Bartsh

Douglas Beasley

Liz Beerman

Cynthia Bland

Kristen Brown

Gloria Brush

Steve Bye

Miguel Cabanela

Casper Cammeraat

Helen Coghlan

Doug Connell

Karen Cook

Laura Crosby

Rosemary Ann Davis

Pam Demmer

Pearl Devenow

Diana Shay Diehl

Ning Fan

Anastasia Faunce

Richard & Ruth Faunce

Milan Faunce-Arnold

Flashlight Photorental Minneapolis

Lynn Garthwaite

Nadia Giordana

Debra Fisher Goldstein

Tai Goodwin

Barb Greenberg

Jennifer Greseth

Lori Hamilton

Shawn Helmin

Jon Holt

Kathryn Homes

Martin Husch

Deb Ingebretsen

Julie Irey

David Jackson

Nancy Johnson

Mark Karney

Darla Keller

Karen Kinoshita

Alexis Kuhr

Maury Landsman

John & Margy Ligon

Kim Lipker

LeAnn Lisana

Marilyn Moore

Kat Moser

John & Hebe Murphy

Gail Murton

Steve Neidorf

Mary O'Keefe

Joseph D.R. OLeary

John A. Olson

Lisa Sangrene Olson

Ann O'Neill

Conor & Lily O'Neill

Brian & Kelly O'Neill

Owen & Liz O'Neill

Rory & Rhonda O'Neill

Eddie Owens

Paul Pecilunas

M. Reimler

Caroline Reiter

Timothy Roman

Lara Hanlon Roy

Bonnie Russ

Kelly Schiffman

Lana Siewert-Olson

Gail Speckmann

Mere Smith

Daphna Stromberg

Ulrich Taglieber

Margie Tate

Simon & Ciara Taylor

Prentice Thomas

Margaret Owen Thorpe

Thomas Valois

Eric Damon Walters

Jay Weir

Kevin Winge

Ellen Wold

Leslie J. Yerman